In Search of a Lost Avant-Garde

MATTI BUNZL

In Search of a
Lost Avant-Garde

An Anthropologist Investigates
the Contemporary Art Museum

The University of Chicago Press ~ Chicago and London

The University of Chicago Press, Chicago 60637
The University of Chicago Press, Ltd., London
© 2014 by The University of Chicago
All rights reserved. Published 2014.
Paperback edition 2016
Printed in the United States of America

22 21 20 19 18 17 16 2 3 4 5 6

ISBN-13: 978-0-226-17381-8 (cloth)
ISBN-13: 978-0-226-41812-4 (paper)
ISBN-13: 978-0-226-17395-5 (e-book)
DOI: 10.7208/chicago/9780226173955.001.0001

Library of Congress Cataloging-in-Publication Data

Bunzl, Matti, 1971–
 In search of a lost avant-garde : an anthropologist investigates the
contemporary art museum / Matti Bunzl.
 pages cm
 Includes bibliographical references and index.
 ISBN 978-0-226-17381-8 (cloth : alkaline paper)
 ISBN 978-0-226-17395-5 (e-book)
 1. Museum of Contemporary Art (Chicago, Ill.) 2. Art, Modern—
Exhibitions. 3. Art museums—Illinois—Chicago. 4. Museums—
Curatorship—Illinois—Chicago. 5. Koons, Jeff, 1955–—Museums. I. Title.
N531.M87B86 2012
709.04′007477311—dc23

 2012017788

♾ This paper meets the requirements of ANSI/NISO Z39.48-1992 (Permanence
of Paper).

For Billy K Vaughn

We are not far from Proust, who understood Flaubert's taste for the imperfect so well.

Pierre Bourdieu, *The Field of Cultural Production*

Contents

MCA 1

It's a night for shiny objects and beautiful people. One of Chicago's particularly brutal winters is—now, at the end of May 2008—finally forgotten. And the Museum of Contemporary Art (MCA) is throwing the party of the year. The long-awaited show by Jeff Koons is opening, and hundreds of museum members have come to revel. There is free food, a fabulous bar, and general merriment. Even a celebrity shows up, Perry Farrell of Jane's Addiction, in town to organize this year's Lollapalooza. Koons, himself, is there too, chatting with admirers, gamely posing for photos, and generally exuding the conviction that art, particularly his own, is bliss.

All this is happening amidst dozens of Koons's iconic pieces. They are split between the MCA's two main galleries, large and cavernous spaces that, in contrast to most other occasions, are left undivided. On the right, *Cracked Egg (Magenta)* dominates the landscape, its surface glistening, a deliciously oversized Easter surprise. It is flanked by smaller items like *Rabbit* and *Lobster*, faithful renditions of inflatable objects that helped

establish Koons's popularity. The sculptures, in stainless steel, aluminum, or porcelain yet somehow warm, approachable, and lifelike, are surrounded by paintings repeating their motifs.

On the left, the same kind of visual exuberance, with the massive *Balloon Dog (Orange)* holding court amidst dozens of other ravishing articles. And in the atrium, floating above the crowd munching on greasy eggrolls, the pièce de résistance: *Hanging Heart (Blue/Silver)*, suspended from the museum's ceiling some fifty feet in the air. It is all quite magical—what Willy Wonka's factory might look like if he were in the toy business.

As I survey the scene, it's clear that the habitués are enjoying themselves. Conversation is animated and even addresses the work on display, not something that can be taken for granted at art openings. I overhear discussions on the longevity of vacuum cleaners and the pros and cons of encasing bourbon in stainless steel. As I line up at the buffet, I overhear a woman rave to a friend: "Finally! A good show!" Talk about a double-edged compliment, I think to myself. What was not to like about other recent exhibits—the career-spanning survey of Richard Tuttle or the hard-hitting show of conceptual art from Mexico City? Then again, this is a different order of crowd-pleaser. Prompting giddy excitement and frequent chuckles of recognition—*Michael Jackson! The Pink Panther!*—Koons's gleaming concoctions even prove useful to patrons in need of a reflective surface to check and adjust their hair.

~ ~ ~

Chicago has the glitz of Koons. But the MCA is far from the only museum anticipating blockbuster crowds for contemporary art during the season. At the very time of the Koons opening, three similarly sensational shows are on display in New York. The Guggenheim is presenting Chinese artist Cai Guo-Qiang's *I Want to Believe*, which actively defies belief with such pieces as *Inopportune: Stage One*, nine seemingly exploding cars suspended in the museum's rotunda, and *Head On*, a sculptural crescent of ninety-nine life-size wolves leaping high into the air and crashing into a glass wall.

Some forty blocks south, meanwhile, the Museum of Modern Art is featuring *Take Your Time*. The show is a survey of work by Olafur Elias-

son, the Danish-Icelandic artist whose aestheticization of nature became an international hit in 2003 when he illuminated the Tate Modern's Turbine Hall with an artificial sun. The MoMA show, which has traveled to New York from San Francisco, is a veritable wonderland of optical gamesmanship, with eerily coruscating waterfalls, tunnels of spectacularly altered light, and cleverly concealed moss walls. It, too, features a piece that hangs from the ceiling—a fan whizzing about the vast atrium in undulating motions, both elegant and somehow threatening, a triumph of low-tech wizardry.

But New Yorkers have to wander across the Brooklyn Bridge for the effort that most resembles Chicago's Koons show. There, they can find © *MURAKAMI*, which has come to the Brooklyn Museum after its spectacular debut at the Los Angeles Museum of Contemporary Art. Often hailed as the Japanese Warhol, Takashi Murakami aims to thrill his audiences with whimsical sculptures and colorful paintings in his Superflat style, derived from manga and anime. His retrospective is sheer visual overdrive, with room after room of smiling flowers and cute comic characters, often installed on Murakami wallpaper featuring more of the same. And, for good measure, the exhibit has a functioning Louis Vuitton boutique, a nod to the artist's design work for the luxury label as well as a sly send-up of institutional critique, the earnest movement seeking to interrogate the complicity of art museums with things like capitalism.

~ ~ ~

New York's critics are decidedly ambivalent about it all. The shows, they decree, are just too easy, all about entertainment, and full of questionable aesthetic choices. Cai Guo-Qiang is "driven by spectacle," Roberta Smith pronounces, reminding her readers that the artist was chosen to orchestrate the opening and closing ceremonies of the Beijing Olympics. Eliasson's work, meanwhile, is "too intent on appealing to our appetite for passive sensation and too readily adapted to corporate design"—this assessment courtesy of Holland Cotter, Smith's colleague at the *New York Times*. And © *MURAKAMI* is little more than a "sleek, stylish and sometimes silly survey" (Smith again).

In Chicago, *Jeff Koons* receives generally good press. But the local newspaper of record, the *Chicago Tribune*, runs a pair of pieces with de-

cidedly different tones. One of them, published just before the opening, is an ironic take on the artist as retail phenomenon. The "Koonsumer Price Index keeps going up and up," the *Trib* quips, noting that a version of *Hanging Heart* recently sold at auction for $23.6 million and that a limited-edition Koons monograph is now priced at $9,000. But it is Alan Artner, the paper's art critic, who *really* tears into the exhibit. His review describes Koons's career as a multidecade sellout, characterized by ceaseless pandering to market tastes. The resulting objects may charm "casual viewers," but they "fail every known test for quality," making Koons's "widespread institutional recognition," and the MCA's retrospective in particular, a veritable sham.

Ultimately, Artner's diatribe isn't all that surprising. By 2008, America's art critics have turned wary of attempts by the country's great museums to stage ever more populist spectacles. Around the turn of the millennium, the Guggenheim Museum scandalized them with the BMW-sponsored *The Art of the Motorcycle* and *Giorgio Armani*, a large-scale retrospective that followed awkwardly close on an eight-figure pledge to the museum by the designer. MoMA shows of the animation studio Pixar and filmmaker Tim Burton, mounted a few years later, fared little better. And with that, it became a critical commonplace to decry museums for their "dismayingly corporate posture," chide them for "acting like the world's longest store window," or diagnose their descent into "popular entertainment hub[s]" (Roberta Smith and Holland Cotter on MoMA, the Guggenheim, and the Metropolitan Museum of Art, respectively).

~ ~ ~

Behind such skepticism was a widespread argument about the art world that has, since the 1980s, steadily gained ground among critics *and* scholars. It holds that the avant-garde is under siege because the foremost art institutions have abandoned it. In an influential book-length essay of 1984, Suzi Gablik posed the issue particularly forcefully. *Has Modernism Failed?* ("yes," the implied answer) was written at a moment of irrational exuberance. The retrograde aesthetic of neo-expressionists like Julian Schnabel and David Salle was taking the art world by storm, prompting Gablik to worry about the possible "death of the avant-garde" at the hands of a market evacuating art's moral authority. Many more treatises

followed in this vein, including fiery enjoinders by Donald Kuspit. For a while, the art historian opened his books with dystopian pronouncements like "Art is at a loss: the avant-garde is over." This was before he went on to declare *The End of Art* altogether.

Notions like modernism's failure or the end of art suggest that there was a moment *prior* to the fall. Indeed, for the lachrymose chorus, such a moment did exist, and it was glorious. It occurred in the middle of the twentieth century when cutting-edge institutions like MoMA and the Museum of Non-Objective Painting, soon to be renamed Guggenheim, fought the good fight for progressive and challenging art. No one has captured this time with greater flair and nostalgia than Jed Perl, the art critic for the *New Republic*. His *New Art City* is a paean to a long-ago era when artists, curators, and philanthropists collaborated, albeit never without tensions, to carve a niche for the avant-garde and defend it against that mortal enemy: *kitsch*.

This, of course, recalls the defining formulation of Clement Greenberg, who, along with MoMA's Alfred Barr, figured as America's foremost prophet of modernism. For Greenberg, the avant-garde was that which was "genuinely new." Kitsch, by contrast, strategically reused the material already available in the culture. "Mechanical" and operating by "formulas," it produced "faked sensations" and "demanded nothing of its customers except their money." Kitsch, Greenberg concluded with disdain, could be enjoyed "without efforts"; the avant-garde, on the other hand, demanded careful attention and close scrutiny. It was difficult, and that was its merit.

For folks like Perl, it all started to go downhill in the 1980s. Art, they argue, lost its seriousness of purpose, becoming ever more market-driven. Museums, meanwhile, began to abandon the difficult for the amusing, trying on a little corporatism for size. And then, it only got worse, right up to the Greenbergian nightmare we now face. Surveying the museum landscape in 2008 and singling out © *MURAKAMI* and Eliasson's *Take Your Time* for special opprobrium, Perl only finds kitsch—"aggressive kitsch."

It is, as I noted, a widely held position. By now, in fact, there is an entire shelf groaning under the weight of critical and scholarly disappointment with the state of our museums. Some of the commentators,

like Julian Stallabrass, Paul Werner, and Chin-tao Wu, proffer more or less overtly Marxist positions. This is reflected in such titles as *Art Incorporated: The Story of Contemporary Art, Museum, Inc.: Inside the Global Art World*, and *Privatising Culture: Corporate Art Intervention since the 1980s*, all of which take the art world to task for its ready complicity with the tenets of global capitalism. Others are less sweepingly political and concern themselves, first and foremost, with the museum as a public good. In that group, we find titles like Kylie Message's *New Museums and the Making of Culture*, Mark Rectanus's *Culture Incorporated: Museums, Artists, and Corporate Sponsorships*, and Bill Ivey's *Arts, Inc.: How Greed and Neglect Have Destroyed Our Cultural Rights*.

~ ~ ~

All of these critiques are powerful and not altogether wrong. They focus attention on the many difficulties—economic, political, cultural—faced by today's museums. And they helpfully identify corporate influence, transformations in the art market, and changing audience demographics as major factors in the life of these organizations. But they *do* have a major flaw. They suffer, generally speaking, from an exaggerated sense of institutional and personal responsibility. Unfettered capitalism has taken over and the public good lost, we are told, because museums and their administrators willfully abandoned their old commitments.

The resulting accounts recall nothing so much as morality plays. When Paul Werner, for example, opens *Museum, Inc.* with the sentence "Actually, I kinda liked Tom Krens," it is easy to see who is cast as the villain in this tale of corporate delirium. Indeed, it is the Guggenheim's long-term director who single-handedly destroys the museum's glorious legacy with his mad dash toward global art domination.

Curators don't fare much better. In *The End of Art*, Donald Kuspit accuses MoMA's John Elderfield, its erstwhile chief curator of painting and sculpture, of ravaging the museum's patrimony with *Modern Starts*. The show, mounted in 2000, reconceptualized the permanent collection by replacing Alfred Barr's teleological vision of art history with a multi-directional account. Ventriloquizing Frank Stella, Kuspit sees the curatorial move as nothing but a "fashionable act"—a form of "commercial entertainment" that, in eschewing judgment and hierarchy, "banalize[s]

modern art" and resembles nothing so much as the "weekly promotions at Macy's." In such accounts, the end of the avant-garde is essentially a failure of nerve, suffered by administrators and curators who should know better than to sacrifice their institutions' heritage at the altar of corporate culture.

I don't disagree with the basic premise of the existing critiques. Like other scholarly commentators, I see the avant-garde as under siege. But I reject the pervasive moralism characterizing so much of the literature. Unlike many of my colleagues, I don't reproach individual actors, be they museum directors or curators, for the current situation. Nor do I accuse museums of willfully betraying their principles. On the contrary, I regard the current developments in America's contemporary art museums as an ineluctable response to the challenges of the day. Where others diagnose a failure of nerve, I thus see a set of strategies devised to persist during a particular economic and cultural moment. If the avant-garde is dead, the museum is not to blame for killing it.

~ ~ ~

How would I arrive at such a contrarian notion? I had the chance to see it all firsthand. Other scholars have had to content themselves with ob-serving museums from the public galleries, thwarted, if they even tried, by institutional reluctance to grant behind-the-scenes access. I had the good fortune of being admitted *into* the fortress by a gutsy organization that was willing to take a chance. And I was there for quite some time. At its core, this book is based on five months of ethnographic research con-ducted at Chicago's Museum of Contemporary Art—the MCA, as every-one in the art world calls it—from January until May 2008.

It was, quite simply, an anthropologist's dream. Maybe not of the tra-ditional variety. My discipline, after all, took shape in the faraway corners of colonial empires, places like the Trobriand Islands, where Bronislaw Malinowski and other titans of early anthropology codified the ethno-graphic method in studies of gift exchange, primitive magic, and the sexual life of savages. Much has changed since the early twentieth cen-tury. We renounced our ancestors' ethnocentrism and stopped speaking of *primitives* and *savages*. And we ventured beyond the global south, claiming the entire range of human experience—whether in the West or

the rest, in villages or megalopolises, at folk festivals or the rarefied institutions of high culture—as legitimate sites for our research.

What has remained, however, is our commitment to fieldwork, a mode of research that privileges face-to-face interactions. It is hardly a perfect method. Our results, for one, are by nature subjective—how could they not be with a research instrument as erratic as a human being? But at their best, they can shed a unique light on the motivations and actions of individuals and groups, allowing for an immediacy that could never be captured through surveys or the examination of printed sources.

Every anthropologist has a slightly different sense of what it means to do ethnography in practice. I like to think of it as *deep hanging out*. The phrase, whose origin has receded into anthropology's endlessly self-mythologizing past, conveys the charmingly oxymoronic nature of a venture that combines impromptu witnessing with systematic reflection and casual conversation with analytic rigor. And it beats another definition, *participant observation*, which, while no less oxymoronic, never struck me as quite so charming.

So there I was, in 2008, deep hanging out at the MCA.

~ ~ ~

My home base was the curatorial department. Located on the museum's fourth floor, adjacent to the galleries typically displaying the permanent collection, it is concealed behind a tantalizingly closed door that conjures a magical realm where art's future is being augured. The reality is rather more prosaic. A large common area with cubicles is lined with an endless row of file cabinets on one side and a half dozen street-facing, glass-enclosed offices on the other. It looks ample enough, but, in actuality, space is at a premium. The curators share the suite with the education department, forcing several of them to double up in their rooms.

Imagine my surprise, then, when I found myself in my own, private office. Francesco Bonami's, actually. The international super-curator, who had masterminded the 2003 Venice Biennale, was in a moment of transition. Just prior to my arrival, he had left his position as the MCA's senior curator and moved to New York. But since he was still involved in several projects that necessitated his periodic return, he retained his

office for the time being. Interns, meanwhile, were beginning to pack up his many, many books. The process would take up the entirety of my stay, the gradually disappearing library lending a vaguely Borgesian air to my surroundings. The state of disposal was never lost on the curators, who were eyeing the soon-to-be-vacated office. Ethnography, I was reminded, is always a two-way street. A famous photograph of Malinowski shows him typing away under a canopy as the Trobrianders look on with intent. He knew he was under surveillance. But he got on with his work, too.

I arrived at the MCA every morning, in time to be there as the staffers filed in. The rest of the day was dictated by their schedule. Meetings were always on the agenda, from informal get-togethers among the curators to complex planning sessions involving the museum's many departments. In between, I chatted with anyone who wanted to talk to me, the presence of "the anthropologist" having aroused the curiosity of a good number of employees. I also made it a habit to take someone to lunch every day. These conversations, typically held at the MCA's restaurant, often lasted for several hours—suffice it to say that I had my fill of Wolfgang Puck's Chinese chicken salad.

I never brought a tape recorder. Their use is standard among anthropologists, and I employed one when researching my dissertation and first book. But over the years, I have come to see those devices as a detriment. True, they allow the highly efficient generation of data, especially in light of new digital technologies. But they also introduce a certain artificiality into the research setting as meetings become guarded affairs and interviews freeze into formality.

Instead of recording, I relied on notes, memory, and the presence of my laptop in Francesco's office. Whenever I had some downtime during the day, I dashed back to the curatorial department, sat down at my desk, and typed away, producing hundreds and hundreds of pages in the process. That corpus of fieldnotes, to use the proper anthropological term, is the empirical backbone of this study. It is supplemented by more conventional sources as well as a series of encounters during the second half of 2008, a time when much of the work I witnessed up close became manifest in the MCA's galleries.

~ ~ ~

This book is hardly the first account of a contemporary art museum. But it is the only one that is grounded in ethnographic evidence. The museum's critics have relied almost entirely on published records—documents, in other words, that are quite removed from an institution's day-to-day operations. At best, those sources are supplemented with interviews. Any inside perspective they can provide, however, is limited, unchecked, as they are, against a museum's realities.

Nothing exemplifies this problem better than Adam Lindeman's widely debated volume *Collecting Contemporary.* The transcripts of thirty-nine conversations with high-powered art world types—dealers, collectors, museum professionals—is billed as the ultimate tell-all. But what we are told appears highly skewed. "We make our decisions *entirely* based on curatorial interest," MoMA director Glenn Lowry emphatically responds to a question on the influence of the market on the museum. That settles that, it would appear, were it not for Lowry's own relativization, which comes a mere two sentences later: "We rarely think about, if at all, the marketplace as an indicator, factor, or even an issue in the kind of decisions we make." So is it *never* or *rarely*, a reader might ask, that MoMA makes curatorial decisions based on market considerations? And why should we believe either one? We are, after all, in a realm of pure assertion.

When I arrived at the MCA, it was my goal to answer these kinds of questions. Only an anthropological approach, it was clear, could begin to do so. Instead of echoing a museum's self-promoting rhetoric or attacking its decision-making processes on the basis of speculation, I would find out what was *actually* going on at such an institution. Sarah Thornton has demonstrated the power of ethnography in her marvelous book *Seven Days in the Art World*, which brilliantly anatomizes such settings as the art fair, auction, and magazine. With the access I enjoyed at the MCA, I would be in a position to write a final chapter, an account of what many would consider the holy grail of the art world.

During the five months I spent at Chicago's Museum of Contemporary Art, the staff was absorbed in the Jeff Koons show. At the same time, countless other exhibitions, in both the near and distant future, needed

to be curated, financed, and marketed. I was there, front and center, hanging out deeply.

~ ~ ~

The title of this book gestures to my main conclusion. And since I realize that the notion of a lost avant-garde sounds rather dejected, let me clarify right away. I'm not contending that the avant-garde is over as such—the use of the indefinite article is key here. What I *am* suggesting is that we should no longer take encountering it at the great museums of contemporary art for granted. Nor should we be particularly disappointed if we don't find it there. The reason for this situation is structural. Contemporary art museums have been subject to a set of economic and cultural transformations that have made a true commitment to the avant-garde all but impossible. Like other scholars, I have quite a bit of nostalgia for the Greenbergian cult of difficult art. But I see it as intrinsic to a bygone era in the life of the American museum.

A touchstone for this argument is my take on Theodor Adorno. The philosopher, notoriously abstruse though he may be, is critical for any analysis of the social conditions of art. And like many other critics, I am indebted to his theorization of art's autonomy as a function of bourgeois society. But I understand his interpretation in historically specific terms. Much like thinking of Marx as a theorist of nineteenth-century industrialization rather than capitalism as such, I see Adorno's position on modern art as reflecting the mid-twentieth-century world in which it took shape.

Renato Poggioli's influential treatise *The Theory of the Avant-Garde* is a crucial lens in this respect. His specification that "avant-garde art can exist only in the type of society that is liberal-democratic from the political point of view, bourgeois-capitalist from the socioeconomic point of view" precisely describes modernism's institutional heyday. Indeed, the civic bastions of benevolent patronage—the MoMAs and Guggenheims—were emblematic of the very *liberalism* that engendered the aesthetic protest foundational to the avant-garde.

This liberal moment, I centrally argue, is over. And the avant-garde went with it. Museums, in this interpretation, did not change course on a whim. Rather, they were forced to reposition themselves in a rapidly

shifting economic and cultural field. That field is no longer character-ized by last century's liberalism; the institutions of today contend with its offspring. *Neoliberalism* has been investigated from countless angles by now. And while there are any number of competing interpretations—I, myself, am most persuaded by David Harvey and Jean and John Coma-roff—there is widespread consensus that the neoliberal order entails the withdrawal of the state and the marketization of all realms of social and cultural life. These, in any case, are the most relevant for the condition of the contemporary art museum.

Neoliberalism has been transforming the entire nonprofit world. But the impact on museums has been particularly stark and, compared to other domains, outright paradoxical. Take academic publishing as a contrast. In the good old days, the work of university presses was com-pletely shielded from market considerations. Books were accepted for publication on scholarly grounds alone, vetted in a suitably arcane pro-cess of peer review that prized specialized expertise over anything else. A manuscript's sales potential never even entered into the discussion. If a book was certain to be relegated to the back shelves of dusty libraries, checked out every couple of decades, that was just fine. What mattered was scholarship for the ages. All this changed with the introduction of market pressures. As university libraries reduced their standing orders (the result of institutional defunding, itself related to neoliberal restruc-turing), academic books needed to start pulling their commercial weight. Peer review remained a factor. But the promise of sales became just as important. The consequences have been drastic, eradicating entire fields of study—scholarship on foreign literatures, for example—from the world of book publishing. More generally, there has been a retrenchment, even decline, with staff positions cut and fewer books issued—the typical non-profit story.

Neoliberalism's effect on the museum is just as strong, but with a peculiar reversal. Instead of causing decline, the neoliberal order forces institutions into a relentless spiral of growth. This book charts this pro-cess in great detail. But the following, while overly schematic, might be helpful as a general orientation: With reductions in public funding, mu-seums need to seek corporate support; to gain such support, they need to attract larger audiences; to bring in larger audiences, exhibits have to

become more spectacular; with more spectacular shows, exhibition costs are spiking; to cover these expenses, institutions need to be aggressive in seeking individual donations; to appeal to donors, museums have to become destinations that properly reflect on their benefactors and the art they lend or donate to the institution; to do this in style, old buildings have to be expanded, new ones erected; the bigger buildings have greater staffing needs and raise overhead costs; to cover these costs, museums have to pursue corporate support even more aggressively; to do so effectively, visitor numbers need to be increased even more, which requires more histrionic shows, with even greater appeal to individual donors, etc., etc. The cycle can commence at any point and its elements are readily interchangeable. No matter how it is drawn, however, what remains is the imperative for expansion.

This spiral of growth affects every aspect of the contemporary art museum. But its repercussions are greatest on the curatorial project and its traditional principles of championing the new and difficult. To the critics, the issue is a simple failure of nerve, the heedless abandonment of modernism's legacy by today's exhibition makers. I argue that the opposite is the case. In my view, curators are the unsung heroes in the struggle over the institution, seeking to preserve an avant-garde vision against ever-increasing odds.

~ ~ ~

I offer my interpretation based on the workings of the MCA in 2008 and the development of the Jeff Koons show in particular. But it is a broader argument about the nature of the contemporary art museum. In a classic anthropological move, I take the MCA as a paradigmatic institution that can stand in for a much larger cultural formation. There is hubris built into this approach. It takes, as Clifford Geertz put it, a "curious case" and "draw[s] from that case some conclusions of fact and method more far-reaching than any such isolated example can possibly sustain." True that. But what the approach lacks in comparative breadth, it makes up in ethnographic depth. If, as Geertz explicated, the "aim is to draw large conclusions from small, but very densely textured facts"—the kind of data that can only be obtained through time-consuming and highly localized fieldwork—a particular site has to represent the whole.

With that in mind, the decision to undertake research at the MCA was ultimately arbitrary, dictated by the fact that I happen to be based in Chicago. If I were a professor at the University of Minnesota (the other campus that interviewed me when I was on the job market, a long time ago), I would have approached the Walker Art Center. In L.A., it would have been the Los Angeles Museum of Contemporary Art; in New York, MoMA, the Guggenheim, or the Whitney.

At all these museums I would have encountered the same basic pattern of institutional culture. The imperative for growth, after all, is everywhere. A quick jaunt across the landscape of contemporary art readily confirms this. Some of the most spectacular examples of new museums can be found in Europe, where the Guggenheim Bilbao (opened in 1997) and London's Tate Modern (2000) have emerged as global trendsetters. But the U.S., too, sports countless recent structures, including, to give but a small sample, the Contemporary Arts Center, Cincinnati (2003), Boston's Institute of Contemporary Art (2006), and the MCA Denver (2007). Expansions have been just as common, with the Walker's enlargement of 2005, the ongoing renovation of San Francisco's Museum of Modern Art, and, most importantly, although it might as well be seen as a new building altogether, MoMA's reincarnation in 2004. But it's not just institutions focusing on contemporary art. General museums, too, have been growing, typically to create more space for the display of their modern holdings. A highly incomplete list would include the Akron Art Museum (2007), the Los Angeles County Museum of Art (2008), and the Museum of Fine Arts, Boston (2010).

Here is how ubiquitous the situation actually is. At a curatorial conference in 2007, a panelist asked the audience, "How many of you are working at institutions that have recently expanded, are in the process of expanding, or have hopes of expanding soon?" Everyone in the room raised their hand.

What's been happening in Chicago, in other words, is entirely typical. This centrally includes the unveiling of the Art Institute's Modern Wing, an occasion the city celebrated with great fanfare in 2009. Abutting Millennium Park, itself a showcase of the contemporary with iconic pieces by Anish Kapoor and Jaume Plensa, to say nothing of Frank Gehry's landmark bandshell, the Modern Wing features the sleek, elegant, and

light-filled design the public has come to associate with the meaning-ful display of modern art. It also sports the byline of a world-renowned architect. In this case, it is Renzo Piano, who was hired to accomplish what Zaha Hadid did for Cincinnati and Coop Himmelb(l)au for Akron, namely to create a building of larger relevance, the kind of edifice that is a destination in and of itself. The architectural jury's verdict was luke-warm. Visitors haven't minded, though, flocking to the Modern Wing in enormous numbers. They gravitate to the newly hung modern and con-temporary collection, so much more at home there than in the museum's original Beaux Arts structure. They also sample the new amenities. Among those is a second gift shop as well as an elegant restaurant, Terzo Piano, run by Top Chef Master Tony Mantuano and a marked contrast to the canteen-like eatery in the old building.

Even more striking when it comes to institutional growth, however, is the Museum of Contemporary Art.

~ ~ ~

The MCA was founded in 1967. Originally housed in a one-story building formerly occupied by *Playboy*, it started as a non-collecting institution devoted to the most advanced art of the day. Its first years were, indeed, heady with the spirit of the avant-garde. The very first show, *Pictures to Be Read/Poetry to Be Seen*, featured text-based art at the vanguard of conceptualism. The landmark *Art by Telephone* followed in 1969, another conceptual classic in which artists were invited to phone in with instruc-tions for pieces that were then assembled on-site. Challenging group shows continued into the 1970s, including the highly controversial *Body-works* (1975), which featured a performance piece by Chris Burden that has become the stuff of legend. Lying motionless under a sheet of glass, he endured for forty-five hours until the MCA staff, concerned for his health, placed a pitcher of water next to his head. Burden got up, smashed a large clock that had sat beside him, and declared the piece over. The parameters for *Doomed* had specified that he would lie in state until the museum's personnel interfered with the sheet of glass, the clock, or him-self. The staff, of course, had been entirely unaware that those were the rules of engagement.

Just as daring were the early MCA's choices for solo shows. In its

initial year of operation, the institution presented Dan Flavin's first museum exhibit, whose apparent emptiness, save for a few unadorned neon lights, was received as the provocation it was. Other adventurous selections followed, with Lee Bontecou (1972), Richard Artschwager (1973), Robert Irwin (1975), and Vito Acconci (1980) all getting their first museum shows at the MCA.

Easily the most storied solos, however, were by Christo and Gordon Matta-Clark. The former was invited to wrap the MCA in 1969, the artist's first action of its kind in the United States and an instant civic sensation. The latter came on the scene in 1978, in conjunction with the MCA's first expansion. The museum had acquired an adjacent three-story building, which, prior to its renovation, became the site for one of Matta-Clark's signature building cuts. It would be his last. A few months later, he died of cancer at age thirty-five, an instant art world saint.

The expanded MCA opened in 1979, having doubled its exhibition space to 11,000 square feet. But the ambition for growth did not stop there. The institution's board, comprised of a small but determined cadre of Chicago collectors, envisioned the MCA as a major player, locally, nationally, and internationally. The goal was to attract larger audiences, offer greater educational opportunities, and, ideally, rival the Art Institute in terms of civic impact. Most acutely, it was felt that the museum needed more space. By the early 1970s, a permanent collection was underway, and as board members and other supporters began to donate pieces, it swelled quickly. And the available facility, even after the 1979 enlargement, proved insufficient, only allowing the sporadic and partial display of the museum's growing holdings.

By the mid-1980s, a grand vision came into focus—a brand new freestanding building in one of the city's premier locations. The spot was found in 1989. The Chicago Avenue Armory, home of the Illinois National Guard, was ideally sited, situated between the lakefront and the city's Magnificent Mile, adjacent to the historic Water Tower. Slated for demolition, the old structure would give way to an edifice that properly reflected the ambitions of the board. As early as 1986, the MCA's trustees had pledged five million dollars as seed money, and with the location secured, a formal fundraising effort was launched. The goal of the Chi-

cago Contemporary Campaign was $55 million; it eventually raised over $72 million.

Josef Paul Kleihues, the German architect who was in the process of turning Berlin's Hamburger Bahnhof into a museum of contemporary art, was chosen to design the new MCA in 1991. His blueprint, a latter-day echo from Otto Wagner's Vienna, was modernist in a no-thrills sort of way, a bunker that beckoned visitors with a square window front and a massive staircase. Most importantly, it promised *real* expansion. The 45,000 square feet of gallery space, a fourfold increase, would allow the continual display of the permanent collection alongside multiple temporary shows. Other attractions would include a three-hundred-seat theater and a generous education center, a two-level gift shop and a large restaurant. The old MCA had drawn about 130,000 visitors a year; the new building was designed for a projected audience of 500,000.

The new building opened on June 21–22, 1996, and with it the MCA morphed from a modest to a large institution. A ready indicator is the size of the staff. Throughout the 1980s, the number of employees had hovered in the mid-thirties. After the move, it settled in around one hundred. And there were many more departments. In 1988, there had been nine. When I did my fieldwork twenty years later, the figure was nineteen, including such new ones as media relations, visitor services, and special events.

~ ~ ~

Such numbers give a good account of the transformation, but so do the shows, particularly those by Jeff Koons. For as it turns out, the 2008 extravaganza was not the artist's inaugural MCA outing. It was preceded by an exhibit mounted in 1988, his first-ever solo museum show in the United States. And just as the later installment was paradigmatic for the new MCA, the earlier one captured the sprit of the old institution.

In 2008, everything was about exuberance. The exhibit was to be a *gateway show*, a concept the MCA used, like some of its peers, to designate displays that could "increase interest and awareness of contemporary art throughout Chicago." Explicitly designed to, among other things, broaden the museum's audience and motivate donors, a certain degree of spectacle was built in from the very beginning.

By contrast, the 1988 exhibit was a resolutely sober affair, serving up Koons's work for earnest aesthetic debate. In his catalogue essay, Michael Danoff, the MCA's director at the time, labored hard toward art historical specification. He finally landed somewhere between the "Figurative Expressionists" (on account of Koons's "interest in transmitting innermost individual feelings") and "socially and politically directed artists such as Hans Haacke."

No such worries in 2008. "Koons 'R' Us," Francesco Bonami proclaimed wittily in a publication that could readily be taken for a novelty catalogue. The art history was light, too—a riff on Brancusi, a nod to Duchamp, and musings on whether Koons was merely the "pastor" or actually the "prophet" for a religion of art.

But it's the covers of the respective catalogues that *really* told the story. The one from 1988 featured a single *Equilibrium Tank*, floating, much like the basketball inside, on the austere plane of post-minimalism. In 2008, we got a merry collage of Koons's best-loved pieces—*Pink Panther, Elephant, Bear and Policeman*. The 1988 volume veiled Koons in high seriousness; in 2008—in a cover designed by the artist himself—we got the visual pleasures of an advertisement.

~ ~ ~

So this was a few years ago. What about since then? Here, we come to one of the intrinsic weaknesses of the ethnographic method. Fieldwork is always undertaken in the here-and-now; but as time passes, it becomes a moment in history, superseded by events transpiring outside the anthropologist's purview. I am deeply cognizant of this issue, not least because, in the time since my research, the MCA has, as any institution of its kind would, undergone some crucial shifts in personnel. One of them was actually underway while I was there—the transition from Robert Fitzpatrick to Madeleine Grynsztejn in the position of director. More recently, Michael Darling succeeded Elizabeth Smith as chief curator, while longterm curator Dominic Molon left the museum to become chief curator of the Contemporary Art Museum, St. Louis. Organizationally, too, there have been changes, including the fusion of the departments of marketing and media relations into a unit on communications and community engagement.

Even more importantly, perhaps, my fieldwork took place just before the cataclysmic economic crisis of 2008, which hit the art world, organized as it is around the production and exchange of objects without use value, particularly hard. For a while, in fact, I was not sure I could write this book. Everything seemed to be collapsing. Gallery sales dried up, auction houses went into freefall, and contemporary art museums became frugal, replacing blockbusters with abstemious shows culled from permanent collections. How relevant, I wondered, was my experience at the MCA? Had I hung out there during some final glory days, the last gasp in yet another period of irrational exuberance that would, one day, be the object of faint nostalgia. Perhaps, I should write about that?

But then, by early 2010 or so, things went back to "normal." Collectors started buying again and bullishness returned to the art world. Soon, fairs celebrated stellar sales and auction houses gloated about new records. And contemporary art museums went right back to planning sensational shows and plotting their next expansion. My research seemed pertinent again. But had it ever lost its relevance? During the crisis, I had returned to the MCA on several occasions. And what struck me most was the continuity between what I saw in 2008 and heard in 2009. In retrospect, I should not have been surprised. After all, the crisis had heightened rather than diminished the economic pressures of the neoliberal regime. When I was doing my fieldwork, the MCA was determined to grow its audience, attract corporate support, and find new donors. If anything, these tasks had become even more urgent during the crisis.

~ ~ ~

Time for a confession. I might have been one of those new donors. So far, I have presented myself as an anthropologist of the art world. That's entirely accurate. But I am connected to the art scene in another way as well. I am also a collector, and this is not an insignificant facet of the story I am telling in this book.

The collecting came first, in fact. It all started in 2003 when my partner Billy and I became properly bourgeois, bought a house, and then, deciding that we had outlived our graduate student days, resolved not to decorate with posters. Instead, we would buy *real art*. Not that we knew the first thing about how that might work. It was on a trip to the

MCA, as it happens, that the venture became more concrete. We saw a piece that greatly fascinated us, and after the wall label directed us to one of Chicago's contemporary art galleries—it happened to be Rhona Hoffman's—we ended up buying it. Another one followed shortly thereafter, and before long, we were hooked.

From the very beginning, the experience of collecting art struck me as highly anthropological. I wasn't venturing to the Trobriand Islands, of course. But on first encountering the art world, such places as Chelsea came off as plenty strange and exotic. It was obvious that its social code was governed by an elaborate set of rules; but what those *were* thoroughly eluded me.

In classic anthropological fashion, I gleaned the culture of the art world only by flouting it. My first interaction with the front desk of one of New York's premier galleries was a prime instance. After seeing a fabulous show, I set out to inquire about prices—this was a shop, no?—only to be met with the curious mixture of pity and disdain extended to those who actually have to ask. With my innocent question, I had signaled conclusively that I was neither moneyed nor connected enough to know that the show was obviously sold out, had been sold out long before the opening in fact, and that the pieces would be going to museums and to some of the gallery's long-standing clients who had spent years on the waiting list. "This is Jasper Johns!" the not-so-nice lady at the front desk of Matthew Marks Gallery had exclaimed in answer to my inquiry. And in one of those *Annie Hall* moments, I realized that what she was really saying was: "You putz! Don't you know *anything*?"

I guess I could have just been turned off by it all. But as it was, such rejection only piqued my interest. And as my fascination with the contemporary art world grew, the idea for a research project started to come into focus. Years ago, I had gone into anthropology precisely because the discipline would accommodate just about any intellectual whim. And I, for one, was ready for a break from researching such perpetual downers as anti-Semitism and Islamophobia in Europe.

But there were a number of ethical concerns. I was perennially worried that my access to the MCA could be related to my standing as a collector. True, with our limited resources, we were hardly at the center of things. But Chicago's art scene is not exactly huge, which meant

that even a couple of purchases conveyed a certain status. My initial approach of the MCA had, in fact, been facilitated by contacts I had made as a collector. And while it took eighteen months of negotiations to work out the specifics of my fieldwork, I agonized over the issue as any overly self-reflexive anthropologist would. Not that any of the curators ever raised an eyebrow.

Ultimately, I compartmentalized. In the art world at large, I might be seen as a collector; at the MCA, I would be an anthropologist. This stance was actually facilitated by the strict ethics code of the American Anthropological Association. I had discussed its principles with the museum staff on several occasions in the months leading up to my research. In addition to affirming a standard commitment to the welfare of my interlocutors and assuring their anonymity in situations where relevant information is not otherwise public, the code bound me to a level of confidentiality that allowed my presence at highly sensitive meetings.

But the main struggle was internal. Having made the commitment to banish the collector from my MCA persona, I never talked about the art I liked, let alone owned. At times, this was torturous. Like most collectors, I can get quite passionate about the work of some artists. But I held my tongue, no matter how tempting it was to insert a name or two into the curatorial discussion of the next big group show. Ultimately, it was a strategy that served me well. Fortunately, I don't have to be quite as strict about it in the book. So I'll finally be able to share my true feelings about Jeff Koons . . .

JEFF KOONS ♥ CHICAGO 2

I'm sitting in the conference room on the fifth floor of the MCA, the administrative nerve center which is off limits to the public. It is late January and the temperatures have just plunged to near zero. But the museum staff is bustling with activity. With four months to go until the opening of the big Jeff Koons show, all hands are on deck. And there is a little bit of panic. Deadlines for the exhibit layout and catalogue are looming, and the artist has been hard to pin down. Everyone at the MCA knows why. Koons, who commands a studio that makes Warhol's Factory look like a little workshop, is in colossal demand. For the MCA, the show has top priority. But for Koons, it is just one among many. In 2008 alone, he will have major exhibits in Berlin, New York, and Paris. The presentation at the Neue Nationalgalerie is pretty straightforward. Less so New York, where Koons is scheduled to take over the roof of the Metropolitan Museum, one of the city's premiere art destinations. But it may well be the French outing that most preoccupies the artist. With an invitation to present his work at Versailles, the stakes could not be higher. Indeed,

when the show opens in the fall, the photos of Koons's work at the Rococo palace, shockingly incongruous yet oddly at home, go around the world.

But on this morning, there is good news to share. As the marketing department reports, Koons has approved the publicity strategy for the MCA show. Most everyone in the group of curators, museum educators, and development staffers breathes a sigh of relief, not unlike the response of Don Draper's team after a successful pitch. *Mad Men*, which made its widely hailed debut only a few months earlier, is on my mind, in fact. Sure, there is no smoking and drinking at the MCA. But the challenge faced by the museum is a lot like that of the fictional Sterling Cooper: how to take a product and fit it with an indelible essence, a singularity of feeling. Jeff Koons is hardly as generic as floor cleaner or facial cream. But given his ubiquity across the global art scene, the MCA presentation still needs a hook, something that can give it the luster of uniqueness.

Koons has history in Chicago, and that turns out to be the key. Yes, he may have been born and raised in Pennsylvania, graduated from the Maryland Institute College of Art in Baltimore, and settled in New York, where, after working as a commodities trader, he became a professional artist. But in between, for one year in the mid-1970s, Koons lived and studied in Chicago, taking courses at the School of the Art Institute and serving as an assistant to painter Ed Paschke. Enough to imagine the MCA show as a homecoming, and the second one at that. The first, it now appears, was the 1988 exhibit, which had paved his way to superstardom and cemented an enduring relationship between artist and city. No one in the room can be certain how Koons *actually* feels about his old stomping grounds. But the slogan stands: Jeff Koons ♥ Chicago.

~ ~ ~

It's a few weeks later. The group is back on the fifth floor. The mood is determined. On the agenda for today is the ad campaign. It will be a "communications blitz," one of the staffers on the marketing team says. It will start with postcards sent to museum members urging them to save the date of the opening. "We need to communicate that it will be a real *happening!*"

"Koons is like a rock star," someone seconds, "and we need to treat him like that." Apparently, Justin Timberlake stopped by the MCA a few

weeks ago, causing pandemonium among the school groups that happened to be touring the museum at the time. "Koons is just like that!" one of the marketers enthuses. "No, he's not," I'm thinking to myself. But for what seems like an endless few seconds, no one has the heart to burst the bubble. Finally, someone conjectures that, Koons's art-star status notwithstanding, people might not know what he looks like. It is suggested that the postcard feature a face shot.

The graphics for the ad campaign and catalogue cover are central to the conversation. We look at mockups, and the marketers share their excitement about the splashy images. There is much oohing and aahing. But, then, a minor hiccup. A curator notes that one of the pieces depicted in the copy will not actually be in the show, the loan request having been refused. Another image presents an issue as well. That piece will be on display, but it belongs to another museum. Maybe it, too, should be purged. No one is overly concerned, though. Given a virtually inexhaustible inventory of snazziness, Koons's oeuvre is certain to throw up excellent replacements.

Splashy images would also be the focal point of an advertorial the marketing department is considering for a Conde Nast publication. Such a piece, to be run in either *Vanity Fair* or *Architectural Digest*, would be written by the MCA but laid out in the magazine's style. It would complement the more conventional press strategies, like articles in local newspapers, and would be on message. This, as signs from the real world indicate that Koons may, in fact, truly *like* Chicago. He wants to attend a Bulls game with his kids while in town. From the standpoint of marketing, it's a golden opportunity. "This artist likes Chicago sports," one staffer gushes, something people would be "pleasantly surprised by." The narrative that emerges is that of the local boy who made good. Indeed, when the official marketing copy arrives a few weeks later, it features sentences like these: "The kid who went to art school in Chicago and loved surrealism, dada, and Ed Paschke and the imagists—that kid made it big."

~ ~ ~

A few weeks later still, back in the conference room on the fifth floor. Today's topic: tie-ins and merchandizing. Some of it is very straightforward, including a proposed relationship with Art Chicago, the local

art fair. Other ideas are more outlandish, like a possible connection to *The Incredible Hulk.* The superhero movie, based on the Marvel Comics and starring Edward Norton, is set to open in mid-June, and the staff member pitching the idea seems to be half joking. But as I look around the room, there are a lot of nods. The show, after all, will feature several pieces from Koons's *Hulk Elvis* series, large paintings that juxtapose the cartoon character with such Americana as the Liberty Bell.

More concrete is a tie-in with Macy's. This past fall, a large balloon version of Koons's *Rabbit* made its debut in New York's Thanksgiving Day Parade. For the MCA show, it could make a trip to Chicago, where it would be displayed at the Macy's store in the Loop. I'm wondering if that might be a risky move. After all, the company is considered something of an interloper in the city, having taken over Marshall Field's beloved flagship store in 2006. But the marketers are ecstatic about the opportunity. "This will really leverage the promotional aspects," one of them exclaims. The word that keeps coming up is "cross-marketing," and I take away that Jeff Koons stuff might soon be everywhere.

Stuff, in fact, is what really gets the group going today. Koons, it turns out, is a veritable merchandizing machine, which means that *a lot* of things can be sold in conjunction with the show. The list of products bearing his art ranges from the affordably populist (beach towels from Target) to the high-end luxurious (designs by Stella McCartney). But the news gets even better. Koons has given the MCA permission to manufacture a whole new line of T-shirts featuring *Rabbit.* We pass around production samples, and everyone agrees that the baby tees, in light blue and pink, are too cute for words.

Then it's time for the food. As early as January, I heard about plans to delight museum patrons with Koons-themed cuisine. Initially, there was some talk of cheesecake, but more recently, the word in the hallways has been cookies. Turns out, it's a go. Koons just approved three separate designs. We're back to oohing and aahing, when one of the marketers suggests that some of the cookies could be signed and sold as a limited edition. Another joke, I think. But he goes on, noting that some people would choose not to eat the cookies so they could sell them at Sotheby's in a couple of decades. The atmosphere is jocund. So when one of the

curators points out that worms would be crawling out of the cookies by then, it's all taken as part of the general levity.

~ ~ ~

The concept of marketing is quite new to contemporary art museums. In the good old days, it was simply not seen as a necessity. Giving avant-garde art a place was the objective, which meant that institutions catered to a small group of cognoscenti and worried little about attracting the general public. All this changed once the spiral of growth started churning. Larger museums required larger audiences, not just to cover ever-increasing overhead but to validate contemporary art museums' reinvention as major civic players.

The MCA is paradigmatic. Until the late 1970s, there was no marketing operation per se. What little advertising was done ran under the rubric of "public relations," which was itself subsumed under "programming." Public relations became a freestanding unit in the 1980s, and by the end of the decade marketing was officially added to its agenda. But it was not until the move into the new building in 1996 that a stand-alone marketing department was added to the institution's roster. The department made its presence felt immediately. Right away, its half dozen members began issuing a glossy magazine, initially called *Flux* and later renamed *MCAMag*, *MCA Magazine*, and eventually *MCA Chicago*. A few years later, a sprightly e-news enterprise followed, keyed to the ever-expanding website.

But marketing is much more pervasive in the contemporary art museum. Just before I arrive at the MCA, for example, its marketing department spearheads the museum's fortieth-anniversary celebration, a forty-day extravaganza with numerous events and free admission. Some of the first meetings I attend at the institution are the postmortems, where the marketers take a lead in tallying the successes and failures of the initiative. There is much talk of "incentivizing membership." Branding, too, is emphasized, particularly the ongoing need to "establish the museum's point of view" by defining the *contemporary*. The latter is especially pressing in light of the imminent opening of the Art Institute's Modern Wing. But the key word that recurs is *gateway*. The MCA, the marketers

consistently argue, needs shows that appeal to "new and broader audiences" and signal that all Chicagoans are "welcome at the museum."

Jeff Koons is their big hope for 2008. In a handout prepared for a meeting in February, they explain why: "Jeff Koons is by far one of the (if not the) most well known living artists today." With the recent sale of *Hanging Heart* making "news even in *In Touch Weekly*" and his participation in the Macy's Thanksgiving Day Parade, he "is doing what no artist has done since Andy Warhol." He is becoming part of the "mainstream." Even more importantly, "the art itself helps to make this a gateway." The "images of pop culture icons and inflatable children's toys democratize the art experience. Even the most novice of art viewers feel entitled to react to his work."

With this, the marketing department takes a leading role in the preparations for the Koons show. Its members help organize and run the weekly meetings coordinating the museum-wide efforts and rally the troops when morale is down. This is done corporate-style, as in an exercise in which staffers go around the table to share what excites them personally about Jeff Koons. The curators can be conspicuously silent when marketing talk dominates the agenda. But that doesn't mean there aren't any tensions.

~ ~ ~

I'm having lunch with one of the curators. We're sitting on the cafeteria side of Puck's at the MCA, the vast, high-ceilinged restaurant on the museum's main exhibition floor. The conversation circles around a loaded topic, the frustrations with the marketing department. "I understand where they're coming from," she tells me, only to add that they may not "believe in the same things I do." I ask for specifics and get a torrent that boils down to this: The curator sees the MCA as a space for adventure and experimentation where visitors encounter a contemporary culture they don't already know. What marketing wants to do, she says, is to give people a pleasant experience amidst items they already like. "If they had their way, it would be Warhol all the time." Individual viewpoints vary, of course. But I'm hearing similar things from other members of the curatorial department. Marketing, they tell me, can be fecklessly populist and insufficiently attuned to the intricacies of contemporary art and artists.

The feelings are mutual, or, to be more accurate, inverted. To the marketers, the curatorial department sometimes comes off as elitist and quixotic. When its members talk about some of the art they want to show, one of them tells me, it can "just sound crazy." "Sometimes," she continues, "I don't even know *what* they are doing." Even more exasperating, however, is the curators' seeming disinterest in growing the museum's audience. "They never think about how to attract more viewers" is a complaint I hear on more than one occasion.

If there is a convergence of views, it is only that the other side has too much power and influence.

~ ~ ~

For a while, I think that the fretting might be personal. Every institution, after all, breeds animosities, petty and otherwise, and the ever-receptive anthropologist would seem to be the perfect outlet. But I am struck that the grievances are never ad hominem. The MCA's employees, in fact, seem to genuinely like and respect one another. This is not surprising. The museum, after all, is a nonprofit whose staffers, no matter how "corporate" in orientation, could pursue eminently more lucrative careers elsewhere. The resulting feeling is that "we are all in this together," a sentiment I hear expressed with equal regularity and conviction.

What, then, is it between curation and marketing? Over time, I come to see the tensions as intrinsic to the quest of bringing contemporary art to ever-larger audiences. The issue, in other words, is structural.

~ ~ ~

When marketers look at contemporary art, they see a formidable challenge. Here is a product the general public knows little about, finds largely incomprehensible, and, occasionally, experiences as outright scary. This is as far as one can be from, say, introducing a new kind of soap. There, the relevance and purpose of the generic product are already well established, leaving marketers to work the magic of brand association. Maybe the campaign is all about fragrance or vitality or sex appeal—what it won't be about is how soap itself is good for you.

Much of the marketing in the domain of high culture works in this very manner. When Chicago's Lyric Opera advertises its new season, for

example, it can safely assume that folks have a pretty accurate sense of the genre. What's more, there is little need to justify the basic merits of the undertaking. Most people don't go to the opera. But even those who find it boring or tedious are likely to accede to its edifying nature.

The same holds true for universal museums. In Chicago, that would be the Art Institute, whose holdings span the globe and reach from antiquity to the present. Marketing has relevance there, too. But much like at the Lyric, the value of the product is readily understood. So is its basic nature, particularly when it can take the form of such widely recognized icons as Georges Seurat's *La Grande Jatte* or Grant Wood's *American Gothic*.

At its most elemental, the marketing of a museum is orchestrated on the marquees at its entrance. With this in mind, the Art Institute's advertising strategy is clear. It is the uncontested classics that get top billing, whether they are culled from the museum's unparalleled collection or make an appearance as part of a traveling show. Mounted between the ornate columns at the majestic Michigan Avenue entrance, a typical tripartite display, as the one from April 2007, looks like this: In the middle, bright red type on a blue banner advertises *Cézanne to Picasso*, a major show on the art dealer Ambroise Vollard, co-organized by the Art Institute and fresh from its stop at the Metropolitan Museum in New York. On the left, a bisected flag adds to the theme with apples by Cézanne and Picasso's *The Old Guitarist*, one of the museum's best-loved treasures. On the right, finally, a streamer with an ornately decorated plate—horse, rider, birds, and plants—publicizes *Perpetual Glory*, an exhibit of medieval Islamic ceramics. A couple of months down the road, the billboards announce a show of prints and drawings collected by prominent Chicago families, an exhibit on courtly art from West Africa, and free evening admission on Thursdays and Fridays. A little later still, it is an exhibit of sixteenth- and seventeenth-century drawings, a display of European tapestries, and the Art Institute's logo.

What's not on the Art Institute marquees is contemporary art. Sure, a canonized living master like my good friend Jasper Johns can make an occasional appearance. But the edgy fare served up by the museum's contemporary department is absent. Nothing announces William Pope.L in 2007, Mario Ybarra Jr. in 2008, or Monica Bonvicini in 2009. The con-

temporary art market may be booming, but the Art Institute's marketers assume that the general public cares only so much.

Their colleagues at the MCA don't have that option. Tasked with marketing a contemporary art museum to an ever-expanding audience, they have to find ways to engage the general public in their rarefied institution. It is an act of identification. "Often I, myself, don't understand the art in the museum at first," one marketer tells me, "but that gives me an advantage. I get where our audience is coming from."

The issue goes far beyond marquees, then, although they are its perfect representation. For what's at stake is the public imaginary of contemporary art. This is where marketing and curation are at loggerheads. The two departments ultimately seek to tell fundamentally different stories about the MCA and its contents. For the curators, the museum is a space for the new and therefore potentially difficult. For the marketers, that is precisely the problem. "People tend to spend leisure time doing something that is guaranteed to be a good use of their time," they implore their colleagues. "That often means sticking with the familiar." And so the stage is set for an uneasy dance, a perpetual pas de deux in which the partners are chained together while wearing repelling magnets.

~ ~ ~

Jenny Holzer is not an easy artist. She came to prominence in the 1980s with text-based work that speaks of power, acquiescence, and the inanities of the human condition. Her signature effort is *Truisms*, a collection of over two hundred fifty self-authored statements—from "a little knowledge can go a long way" to "your oldest fears are the worst ones"—that she deploys in various domains, from galleries and museums to various cityscapes. In the 1990s, she expanded her textual inventory to include the work of about a half dozen writers, including Wisława Szymborska and Henri Cole. While moving LED signs are her preferred medium for *Truisms*, the latter are projected onto vast surfaces in slowly moving bands of text. With her critical engagement of public space, Holzer has always been understood as a political artist. Her most recent work makes this even more overt. It is a series of large paintings of declassified documents pertaining to the activities of the Bush administration.

While I'm at the MCA, the museum is preparing a major exhibition

of Holzer's work. It is one of the biggest shows of the year. Scheduled to open in October, *PROTECT PROTECT* is slated to occupy the same galleries as the Jeff Koons extravaganza, just weeks after it closes. After Chicago, it will travel to the Whitney Museum in New York, the Fondation Beyeler in Basel, and the Baltic Centre for Contemporary Art in Gateshead, England.

I sit through a lot of meetings on the Holzer show. They are nothing like the ones on Koons. The mood is earnest, even subdued. The exhibit will focus on the later work, giving it an especially strong political bent. To the curators, this seems highly relevant. The show, after all, will be on view during the 2008 presidential election. It's the marketers who are largely silent now. I get the feeling that there won't be a Jenny Holzer baby tee—and no cookies either.

After one of the meetings, I find myself at lunch with one of the marketers. She is worried. Jenny Holzer might not work well as a gateway show, she tells me. Some folks might find the work difficult, she says, referring to the efforts required to actually read the texts. She is also concerned about the political content. "It will offend some viewers." Even worse, it could leave folks disengaged. People, she contends, can get sick of politics, and they might not want to deal with it when they go to a museum. I fear that she could be right. And I feel bad because her comments suggest that Holzer might not find the large audience she deserves.

I try to brighten the conversation by recalling a lovely experience I had at a Jenny Holzer exhibit. It was in Vienna, in the summer of 2006. Holzer was having a big show at the MAK, the city's famed museum of applied art. The centerpiece was a vast exhibition hall animated by chunks of text that were scrolling up and down the floor, walls, and ceiling. The only physical objects in the otherwise darkened room were four enormous beanbags. Billy and I checked out the show on a sweltering day. Exhausted from the heat and lapping up the museum's air conditioning, we plopped ourselves down on one of the beanbags. We didn't move for the next three hours. It was magical, as if floating on a soft cloud, the writings of Elfriede Jelinek, Austria's Nobel Prize–winning author, washing over us. Could be, we even drifted off.

As I'm telling my story, the eyes of my lunch date are lighting up. "Now there is something I could market!" she says excitedly as I finish.

I'm not sure if she's serious. But I'm surprised, flattered, and a little disturbed. Anthropologists are not bound by *Star Trek*'s prime directive of never interfering with the internal developments of an alien civilization. But the vision of a marketing campaign based on my account—something like "Come to the MCA to take a nap"—makes me uneasy. Several weeks later, I am relieved to find out that the MCA galleries are not big enough for the kind of presentation I experienced in Vienna. There won't be any beanbags in Chicago, and the advertisements end up focusing on Holzer's LED pieces and the political valences of her work. And quite successfully at that.

~ ~ ~

Karen Kilimnik is not an easy artist either. But this one goes in a different direction.

In February of 2008, the MCA presents the first major survey of Kilimnik's work. The show spans her entire career, from the scatter pieces that made her name in the 1990s to the drawings, photographs, videos, and paintings that constitute her ongoing practice. All of the work has a somewhat gothic sensibility, rendering a dystopian fascination with consumer culture in an adolescent style of faux-naïveté. Formally, though, it is highly varied. The scatter pieces invoke the territory of a drug-addled teenager following a minor explosion, while the drawings and videos recall the more orderly, albeit no less creepy, world of obsessive fan culture. The paintings, by contrast, appear to be exercises in romantic nostalgia, with moonlit landscapes, cute animals, and celebrities in suggestive poses. To Kilimnik's many admirers—the artist is a darling of the jet-setting curatorial elite—they are the ultimate parodic intervention, especially when collaged into salon-style hangings. One of those installations is in the show, set into a discrete chamber lined with ornate red wallpaper and featuring a plush red circular sofa to facilitate wistful gazing. Appropriately enough, it is called the *Red Room*.

But the stakes are different from the start. In contrast to the Koons and Holzer exhibits, which are created *by* the MCA, the Kilimnik show originates at another institution. It premiered almost a year ago at the University of Pennsylvania's Institute of Contemporary Art and arrives in Chicago at the tail end of a national tour that also took it to the Mu-

seum of Contemporary Art, North Miami, and the Aspen Art Museum. The MCA is the biggest venue by far. While the exhibit just about filled the other institutions, the Chicago presentation occupies only one side of the fourth-floor galleries and coincides with nine other shows. The curators *do* take it seriously. After all, they opted to host this particular exhibit when countless other traveling shows were available as well. And yet, there is an inherent difference between serving as the local coordinator for someone else's exhibit and curating your own show. Maybe, this is what gives marketing more of an opening for their ideas.

In its basic design, the Kilimnik exhibit is a heady occasion. One would expect nothing less from the Institute of Contemporary Art, one of the country's leading venues for advanced art—it was the first museum to show Andy Warhol—ever since its founding in 1963. As a comprehensive retrospective, it seeks to identify Kilimnik's unique contribution ("bringing a haunting and contrary sense of beauty to contemporary art"; "re-materializing a quest for the romantic sublime") and makes a methodical argument about her aesthetic trajectory, from an "essentially collage-based practice into a full-scale and theatrical form of production." The MCA's curatorial department prepares a similarly brainy rationale. It locates Kilimnik in an art historical continuum of precursors (Robert Morris, Barry Le Va) and descendants (Hernan Bas, Christian Holstad, Banks Violette) and stresses the "criticality" inherent in her "sense of romanticism and nostalgia."

Some of this language does make it into the publicity material. But the overarching thrust is somewhere else entirely. This starts with the image used to advertise the show. It's a dreamy portrait of Leonardo DiCaprio, pale-skinned and dressed in period costume, gazing at the viewer with a forlorn look of longing. In the show, the small piece is one among dozens in the *Red Room*, a mise en scène deriving its effect from the anarchic variety of subjects (portraits, still lives, reveries), mediums (painting, drawing, photography), sizes (miniature to gallery-filling), and presentation styles (elaborately framed to bare). In that context, the "criticality" of the image is plausible. But in the isolation of the MCA campaign, it recalls nothing so much as a Sunday painter capturing her idol.

The illustrations on the website support the anti-elitist message, with paintings of Snow White and a Lipizzaner Stallion, along with a drawing

of Brigitte Bardot. Not rendered visually is the *Red Room* itself; nor, for that matter, are any of the other installations. They only appear in the texts, which tell of a fun-loving artist who "sprawls detritus from decades past" and reconfigures galleries as shooting ranges.

On her way from Philadelphia to Chicago, Karen Kilimnik has gotten a little bit easier.

~ ~ ~

It's the middle of February. I'm back in the conference room on the fifth floor. It's noisy. Below us, the Kilimnik show is being installed. There is hammering and sawing as the *Red Room* takes shape.

But once again, all eyes are on Jeff Koons. Today, the marketing team wants to discuss the likely audience for the exhibit. As the conversation gets going, I realize that the topic hasn't really come up in my work so far. I'm a little shocked, even embarrassed. I have been at the MCA for six weeks, but not once have I asked the curators about the actual people coming to see their shows. Our exchanges have rounded the globe, from the latest exhibits in Los Angeles, New York, London, and Berlin to the never-ending circuit of biennials. But the folks taking in the art in the museum's galleries have been missing. Perhaps, I think to myself, the question would have been too obvious. Who comes to a museum of contemporary art? People who like contemporary art, of course.

Listening to the discussion, I quickly realize how simplistic my assumption is. Simplistic and *wrong*. As the marketers produce reams of data on the museum's audience, a much more nuanced picture emerges. Not only do they know a great deal about the visitors' demographic makeup, they have ample qualitative evidence on the motivations for attendance. Some of the surveys and questionnaires focus on the MCA experience as such; others put the institution in the context of Chicago's variegated cultural landscape. As a result, the marketers have a pretty good idea why a family of four might choose to spend a Saturday afternoon at the museum instead of, say, the Shedd Aquarium. The social scientist in me is impressed.

The key finding I take away is this: the percentage of people who come to the MCA because they are tried-and-true afficionados of contemporary art is small. More than small. On reflection, this *does* begin

to make sense. The contemporary art world may be expanding. But its core has not substantially changed since the museum's founding period. It is still comprised of artists (and art students), gallerists, curators, and collectors; and while the absolute figures in all these categories have risen, the increase, in a city like Chicago, is in the hundreds rather than the hundreds of thousands. These folks are the cognoscenti who were around in the 1960s and '70s, long before a professional marketing operation got going. And they are still here today, which is why, I come to realize, the marketers are quite right to take them for granted. Sure, the art worlders might be charmed by a fun promotion and even gobble down the occasional Jeff Koons cookie. But, in the end, they will come to the MCA in any case.

Who else, then, could be enticed by a museum of contemporary art? This is what the marketing folks seek to gauge from their mountain of data. And since, unlike mine, theirs is an *applied* social science, the goal of the exercise is clear: to turn intelligence about potential audiences into actual visitors. For the Koons show, this translates into a typology of four "target audiences," all of them characterized by a unique set of motivations, to be addressed, in turn, by particular marketing strategies. The first two are out-of-towners; the last two are local.

Summer Tourist. The typology starts straightforwardly enough. Chicago is a national and international tourist destination, especially in the warmer months. Visitors, the marketers note, come for the architecture, the shopping, and—particularly in regard to the "Midwestern feeder markets"—the general, urban experience. These folks, they go on, may not be particularly interested in art, but they may well be open to visiting a museum during their vacation. I'm distracted all of a sudden by memories of numberless Europeans blocking my view at MoMA. But I snap back to attention when the marketers affirm that it shouldn't just be the Art Institute that gets visitors this way. Tourists, they say, want to discover the "hot Chicago"; and with Koons, the MCA is a "must visit of the summer." What is less clear is how to reach the tourists before they overdose on art at the juggernaut down Michigan Avenue.

International and National Art Lover. No such problem there. A nice ad in *Artforum* or *Frieze* should do the trick. But I am struck by what might be a fundamental misrecognition underlying the idea of market-

ing the Koons show to an international art world elite. What the MCA team has in mind are "art jet-setters" who will come to Chicago "to take in this once in a lifetime opportunity." True, I think to myself, there are plenty of folks in the art world with the means and leisure to come to the Windy City for a quick spot of Koons. But why would they? Koons's work is everywhere, in permanent collections and temporary exhibitions, catalogues and art magazines, and, quite relevant for the category in question, the homes of countless patrons. It is far too familiar, in other words, to arouse the interest of true jet-setters. For them, travel tends to be motivated by the chase of the cutting edge, as in 2007's *Grand Tour*, which saw the art world traipse across Europe to catch the Venice Biennale, Documenta, Münster Sculpture Projects, and Art Basel. A special trip to Chicago, by contrast, hardly seems warranted, no matter that this particular Koons show will only be seen at the MCA.

Local Culture Vulture. Now, here is where it gets promising. "Culture vultures" are the most frequent and dedicated consumers of local artistic fare. They are characterized, I learn, by their eclectic tastes and interests—from theater and dance to music and literature—and a desire to "be the first" when it comes to discovering the "next big thing." The visual arts are not a central preoccupation for them as such, but the MCA is very much on their radar. The task, then, is to "get our message in front of them." While the marketers describe the ads that will soon start running in places like the *Chicago Tribune* and *TimeOut Chicago*, I write on my note pad: "Jeff Koons *is* the next big thing!" There is only one hitch. Marketing is worried that "Chicagoans spend summers outdoors." Reaching the culture vultures at their seasonal habitat will thus require "innovative ways." What ensues is an amusing discussion about the pros and cons of beach advertising.

Almost Here's. This is also relevant for the last category, which is as elusive as it is appealing. In contrast to the vultures, the almost here's have no pronounced interest in the arts and culture. They are consumers of urban leisure more broadly. To get to them, the MCA has to compete with Chicago's myriad other attractions, the city's ballparks and recreational greens, its culinary temples and unending string of festivals. The only chance is to present something they will consider *truly* extraordinary. As the marketers put it, "they need a reason to come." Warhol was

such a reason, turning the figment of almost here's into huge crowds of actually here's. That was in 2006 for *Andy Warhol/Supernova*, and the team is confident that it can be so again with Jeff Koons. I am persuaded. When I took in the Warhol show—a relatively minor affair of two dozen narrowly focused pieces—I was startled by the throngs of people, not to mention the fact that I was there with a close friend, who, having spurned all my previous entreaties, could, all of a sudden, not wait to get to the MCA. I expect he might want to return in the summer to see Koons. He does.

As I reflect on marketing's typology, a certain irony hits me. The very reason my friend, the almost here, is attracted to the Koons show is what might render it less than thrilling for international and national art lovers. He is keen to see familiar art by a familiar artist; they are quick to scoff at overexposed art by an overexposed artist. But even if a gateway show is not for everyone, marketing's focus seems right on the money. After all, the number of almost here's is huge, encompassing most everyone in the greater Chicago area. All that's necessary for the MCA to hit its goal is to convert a few of them into regulars.

~ ~ ~

Koons might do the trick. But how else do you get the almost here's into the museum? Turns out, I had seen it up close. I just hadn't realized it.

Flash back to the spring of 2004. I was still a relative newbie to the art world, anxious to experience all that it had to offer. And I was excited. I just received my first invitation to a major art opening. It came from photographer Luke Batten. Luke, who collaborates with fellow artist Jonathan Sadler under the moniker New Catalogue, organizes his practice around the interrogation of stock photo agencies. At times, this results in the production of absurdist series for imaginary clients (*Ivy League Tree Trunks*, *The Lost Cheerleaders*, *The Incredible Wonderful Complicated Dag Hammarskjöld*); on other occasions, it generates solutions to visual problems in the real world (e.g., designing covers for the contemporary classical music label New Amsterdam Records). Luke and I met shortly after he was hired to teach photography at the University of Illinois. We bonded over our love of talking art and the fact that we both split our time between Champaign and Chicago. We have been fast friends ever since.

In 2004, Luke's career was at an exciting moment. New Catalogue had just come off its first gallery show, followed in short order by an invitation to exhibit at the MCA. Luke and John would be part of 12 × 12—the museum's series of monthly shows by emerging local talent. It was a huge deal. Since the venture's inception in 2001, every young Chicago artist had been clamoring for a 12 × 12, and it had already helped launch such illustrious figures as Rashid Johnson, Clare Rojas, and Siebren Versteeg. Other young stars—Melanie Schiff, Brian Ulrich, Jason Lazarus, William O'Brien—would follow over the next few years.

The opening was on a Friday night in May. I was running late. And when I scampered into the museum, I thought I must have gotten the date wrong. A sound system was blaring throughout the MCA's atrium, which was filled with a gaggle of coolly dressed twentysomethings vibing to the music. There were hors d'oeuvres and chitchat. And while I'm no expert on heterosexual pickup scenes, I was pretty sure that I had just stumbled onto one.

Luke was nowhere to be seen. Circling through the near-empty galleries, I finally found him off to the side of the coat check. He was chatting with Francesco Bonami, just outside a small room hung with nine prints from the hilarious series *Big Ten Co-eds with Ski Masks*. John was there, too, as were a bunch of friends. They were having their opening while, all around them, a rousing party was in full swing. It seemed rather surreal, and it was not until later that I understood what was going on. New Catalogue's opening, like all 12 × 12 vernissages, took place on a First Friday.

~ ~ ~

First Fridays are the brainchild and triumph of the marketing department. No initiative brings more almost here's to the MCA than the bashes, held, *nomen est omen*, on the first Friday of each month. Eagerly anticipated by Chicago's smart set, they continue much in the fashion I first encountered them—a pageant for the city's young professionals. Even better, First Fridays pay their own way via ticket sales and corporate sponsorships. No surprise there. The demographic could hardly be more desirable.

But there is an institutional price to pay for this success. It weighs on

the relations between the marketing and curatorial departments. Simply put, the curators feel fundamentally ambivalent about First Fridays. It's hard seeing folks come to the MCA for the party rather than the art. And it's particularly tough when the fête overshadows a concurrent 12 × 12 opening and the artist it is intended to honor. Which is to say, always.

Indeed, First Fridays are a fixture in the city-wide scene quite apart from any connection to art. *TimeOut Chicago*, the urban professional's local handbook, regularly includes it in features with titles like "Mating Habitats" that promise to "track down singles in the wild." There, First Fridays receive high marks for the agreeable wardrobes: "women quickly shed coats to reveal skin-tight cocktail dresses"; men "come in hip, slim-fitting duds and the occasional flannel." But what's really exciting is the "digital dating bar" that matches patrons by "personality type and compatibility." This, *TimeOut* raves, "gets single-heavy cliques mingling" and assures that most everyone ends up with the "grand prize: some new numbers in their iPhones." The fact that there's art all around this doesn't even merit a nod.

Such disregard, it needs to be said, is not the fault of the MCA's marketing team. Whenever they create copy for First Fridays, there *are* references to art. But the slogans can be flippant ("We like a little attitude with our art"), limning the museum as little more than the backdrop for a theme party ("Looking for a reprieve from the typical Friday night? There's no better place to meet your fellow art-enthralled friends than First Fridays"). And the marketers do what they can to hype up the crowd, including snapping photos to be used in future ads. It's only mildly risqué, but it nonetheless provokes ire. As one curator tells me with resignation, "It's always about this: 'isn't it fun—isn't it exciting!'"

As I reflect on these sentiments, I realize that, in a nutshell, the issue is this: in marketing the MCA to new audiences, does art have to be the selling point? For the curators, the answer is a self-evident *yes*—what else, in the end, is the raison d'être of an art museum? The marketers see it more pragmatically. If a constituency, especially one as coveted as the First Fridays crowd, is attracted to the MCA because of its hip scene, then that's what the museum should give them. Bodies are bodies, after all; and who knows, a social butterfly might always be reborn as a culture vulture.

FEAR NO ART 3

I love the MCA's tagline! What could better capture an institution's sense of adventure and discovery? I'm always delighted to see it flutter on a banner somewhere in Chicago, marking the city as aesthetically progressive territory. And if I were into T-shirts with clever lines, I would buy some—slogan proudly emblazoned across the chest—from the ample piles at the museum gift store. Most of all I like the sheer sass of the sentiment. In one register, it beckons seductively, whispering "come hither" to all those who are still on the fence about contemporary art. In another, it practically screams at you to get with the program if you want to be part of the relevant conversations. It's exultation and challenge and positions the museum at the perpetual cutting edge. As the museum flier says: "The MCA is not for the timid or those who prefer polite art. The MCA gives you art that riles, asks questions, makes you laugh, and messes with your head. This is art for those who love the thrill of the chase, wherever it takes them." *Fear No Art*—indeed!

If only . . .

It's early January. I've been at the MCA for only a few days. And while I have nothing to compare it to, the atmosphere strikes me as tense. I quickly learn why. There is a big issue with the Jeff Koons show. The artist's communications have been sporadic. But two things have become clear: Koons envisions a wide-open floor plan, and he wants to exhibit *Made in Heaven*.

This may sound innocent enough, were it not for the nature of *Made in Heaven*. Something of an outlier in Koons's oeuvre, the series dates to the early 1990s and his brief, ill-fated marriage to Ilona Staller, better known as Italian porn actress La Cicciolina. Conceived as an exuberant and baroque celebration of procreation, *Made in Heaven* features some icons of bourgeois bliss, including kitschy sculptures of flower vases and groomed poodles. The bulk, however, is a set of paintings that plops Koons and Staller right into an Edenic space of uninhibited sex. These images caused a huge stir when they were first exhibited at the 1990 Venice Biennale and have lost little of their potency since then. Indeed, pieces like *Ilona's Asshole* read as straightforwardly pornographic, not only depicting Koons and Staller in the act of intercourse, but, at 90 by 60 inches, practically beckoning the viewer into a study of individual scrotal hairs.

The MCA may abhor polite art. But no American museum can ignore the problems that attend the presentation of such material.

Not that it can't be done. In 2005, for example, the institution featured a large installation by Thomas Hirschhorn, the Swiss political artist–provocateur. Part of Franceso Bonami's ambitious *Universal Experience: Art, Life, and the Tourist's Eye*, the piece reflected on the global moment by anarchically juxtaposing media coverage of the Iraq war, Middle Eastern tchotchkes, and pornographic clippings. It was quite the in-your-face environment. But it was also safely tucked away, sequestered in a perimetric gallery on the MCA's fourth floor, guards at the entrances at all times.

That can't happen with the Koons show. For one thing, it will occupy the two central galleries on the museum's main exhibition level. And while those can be readily partitioned into discrete chambers, that, of

course, is not what Koons wants. For my part, I am curious why the artist prefers an open floor plan. But for everyone around me, the reasons hardly matter. All the MCA staff can think of is the prospect of *Made in Heaven* visible from every angle on the floor. Oversized porn, it should go without saying, is not part of the gateway concept.

Nor, I quickly learn, is it conducive to securing corporate sponsorship. In one of the many meetings on the *Made in Heaven* issue, the development department recounts its efforts. Their interlocutors, the fundraisers report, are squeamish. Even worse, the company they have targeted to be the show's main underwriter has made it clear that there can be no commitment until there is a plan for *Made in Heaven*. More handwringing.

But it's the education department that is most anxious, and in meeting after meeting its members stress the urgency of the situation. For them, *Made in Heaven* is quickly turning the Jeff Koons show from boon to bust. "I am so concerned for families," one educator agonizes, only to add a sigh that speaks to the burden of it all: "the rest of the show is such a joy for children." She says this while looking longingly at the latest checklist. Like all the previous ones, it features one blown-up toy after another.

For weeks, the scrambling for a viable approach continues. Minimally, it is agreed, viewers need to be given a "choice" about encountering *Made in Heaven*. But no resolution is in sight. And with that, the alarm bells keep ringing.

~ ~ ~

While all this is happening, I get a visit from my friend and colleague Brett Kaplan, who teaches comparative literature at the University of Illinois. With a Ph.D. in rhetoric from Berkeley (Judith Butler's department), she is one of those high-end theoretical types who can talk Adorno with the best of them. At heart, though, she is a cultural critic, responding to works of art that powerfully touch her aesthetic imagination. Many of those are in the realm of Holocaust representation, and she has produced ambitious readings of Anselm Kiefer and Christian Boltanski, among others. Right now, she is working on a project with Luke Batten on the transformation of Hitler's mountain estate.

Art comes naturally to Brett. She grew up in New York in the 1970s and '80s, the daughter of a prominent film scholar who was part of the downtown scene. A generation earlier, Morris Louis, the color field painter, was a family friend. Her enthusiasm for art is contagious. In fact, Brett likes to claim that she was the one who infected me with the art bug.

We talk, as we always do, about the must-see shows of the moment. I tell her about the Karen Kilimnik exhibit that's about to open at the MCA and mention *Girls on the Verge*, a photography show on adolescence at the Art Institute. Brett, who has two little girls, is interested. Then we move on to New York. She is about to head there and is looking forward to a bunch of gallery exhibits. But mainly, she wants to go to the Guggenheim to see Cai Guo-Qiang's *I Want to Believe*. "The kids will love that show," she says with excitement. I have every reason to think she is right. After all, what child wouldn't be entranced by the sight of a bunch of blazing cars dangling down the Guggenheim's spiral ramp?

Going to the Guggenheim won't be a first. At ages five and three, Brett's daughters are old museum pros. They are regulars at various institutions, visiting the Art Institute's Family Room and taking in Kids@ Krannert, the all-day extravaganzas of art projects, dance, music, and storytelling held twice a semester at the campus museum of the University of Illinois. And Brett is far from the only professor who proudly displays the results of such outings on her office door.

I ask Brett about her own childhood. Was she a museum regular like her girls? Brett thinks about it for a moment. "My mom always took me to MoMA," she finally says. "We had this game we would play, walking through the galleries and guessing the artists." What about activities, I ask, making masks and tutus like her children do when they visit museums? "No," she replies, "but that would have been so much fun!"

~ ~ ~

Over the last thirty years or so, the educational mission has steadily gained prominence at America's contemporary art museums. Once again, the MCA is paradigmatic. Its education department has multiplied from one person in 1980 to ten by the time of my research, a rate of growth that goes far beyond the institution's general expansion. The

reason is clear. With the aggressive pursuit of new audiences, the need for educational services rises exponentially. Marketing, after all, is only supposed to get people in the door; once they are inside the MCA, it's the job of the education department—along with visitor services, the folks sitting behind the ticket counters—to take care of them.

In the early days, this was pretty straightforward. With the MCA populated mostly by art world insiders, educators could presume a baseline of knowledge along with a generally favorable predisposition toward the project of contemporary art. The aficionados, moreover, tended to show up primarily for openings, and with an often empty museum, the educational stakes were quite low.

All this changed with the museum's expansion. The attendant democratization of the audience brought a degree of racial, class, and educational diversification, and this in turn transformed the institution's didactic enterprise. No longer pitched at an intrinsically understanding and sympathetic viewership, it is now assigned to ease a general public into the experience of contemporary art. The MCA educators recognize this as a demanding task, one that involves stewarding folks through potentially difficult terrain. Whenever I hear them talk about the job, my mind conjures flight attendants trying their best to calm nervous passengers.

But how does this work in practice? Museum education encompasses a wide range of things, from the creation of exhibition brochures to the organization of gallery talks and artist lectures. Like marketing, though, it does have an elemental form. For the purpose of advertising the institution, that form is singular—the marquee at the front of the museum. The educational building block, by contrast, is ubiquitous: the *wall label*.

Wall labels are a hallmark of all museums. But they have particular salience at institutions focusing on contemporary art, where—in addition to providing the basic information on artists, titles, and provenance—they need to explicate unfamiliar and challenging material. What exactly the labels should say, however, is another matter. And so is the level at which it should be said. Wall labels may be a museum's pedagogical front line, but they are also a fault line, particularly between education and curatorial departments.

The perennial tug-of-war is the stuff of classic museum lore. Cura-

tors draft possible texts; educators edit them; curators complain about the edits; educators complain about the complaints. The issue is always the same. The initial texts are too sophisticated for the general audience a museum seeks to attract, and the curators are loath to "dumb them down." Curatorial interns can be particularly bad, the temptation to show off the latest theories and jargon being just too great. After all, even a "term like *minimalism*," I learn when talking to educators across the museum landscape, "cannot be left unexplained." Someone "without an already existing art background" would "simply not know what it means." The texts that typically result may not be composed at the sixth-grade level of the average American reader. But even with that concession, they tend to land on the educators' side of the line. This is not surprising. The ultimate responsibility usually rests with them.

So much for the wall labels. But the biggest educational transformation by far comes with the *kids*. The MCA is typical in this regard. Like all of its peer institutions, it is full of them. On weekdays, they saunter through the galleries with their school classes; on weekends, they race around the museum with their parents.

It wasn't always like that. True, the MCA never disallowed children the way some elite, private institutions do to this day. But even without formal age limits à la New York's Frick (ten years) or Neue Galerie (twelve years), the old building was not exactly teeming with kids. In those days, that simply came with the territory, free bus service for Chicago Public Schools notwithstanding. A contemporary art museum was just not seen as an obvious destination for children.

Nothing could be farther from the present situation. With the MCA's evolution into a large civic institution, outreach to Chicago's youth has become a top priority. And the resulting offerings by the ever-growing education department are tremendously varied, from events targeting toddlers to programs designed for high schoolers.

But none of this is a straightforward proposition. Making a contemporary art museum accessible and appealing to a young demographic, after all, involves more than printing a few colorful brochures for parents and teachers. It requires the formulation of a whole new institutional narrative, one that is tailored to a vastly different intellectual and experiential horizon.

And it should be no surprise that the kid-friendly version of the contemporary art museum can run up against its curatorial vision.

~ ~ ~

Guard: "A kid went through here."
Curator: "What?"
Guard: "Yes, he crawled right through, before I could stop him."
Stunned silence. The kind that suggests real trouble.

Just a few minutes ago, things were so good. Sure, it's still freezing outside. But the worst of winter seems to be over. And inside the museum, I am taking part in what has quickly become one of my favorite institutional rituals. Once a month, always in the morning before the MCA opens its doors to the public, the curators and registrars lead a walk-through of the current exhibits. In attendance are the museum's security guards. Visitors regularly ask them about artists and shows, and the rounds give them the wherewithal to respond to the queries. Everyone else at the museum is welcome, too, however. Today, that includes several members of the central administration. They clearly enjoy the break from the endless crunching of budget numbers, and there is a lot of cheerful back-and-forth about the pieces on display.

And speaking of back-and-forth. There is another purpose to the monthly ritual. It is a chance for the curators to hear from the guards about how people interact with the works in the galleries. They want to know which paintings prompt questions, what sculptures cause consternation, and if a photo has made someone cry. Most importantly, though, it is a chance to assess safety issues for visitors and works of art—part of an impressive array of controls ensuring standards at the institution. It is in this context that a shy security guard points to the large work in the middle of the gallery where the incident happened—where, despite the sign saying "Please Do Not Touch" and the line encircling the piece on the ground, a boy clambered right in and through.

Few things are worse for a curator than the endangerment of a work's physical integrity. After all, to curate literally means *to care for*—a task every curator I know approaches with utmost reverence and responsibility. I say *few*, because what arguably *is* worse is the endangerment of a viewer *by* a work of art. And this is what brings our leisurely morning

stroll to such a crashing halt. For the undermined piece is a cut-out of a building's façade.

Yes, the group is standing in the middle of the Gordon Matta-Clark retrospective. All around us are hulking objects—faux-brick exteriors, wooden windows, roofing shingles. The guard is indicating where the kid crossed the line, and I wonder if the shock is caused by the fact that, all of a sudden, the piece seems nothing but sharp edges and splinters.

Quite apart from such optical disquiet, the work of Matta-Clark remains a challenge to this day. The son of famed surrealist Roberto Matta, he trained as an architect but turned that foundation against itself by developing a practice he referred to as Anarchitecture. It was conceptually and literally deconstructive, finding its definitive expression in his celebrated building cuts. These were site-specific interventions that altered structures by removing walls, floors, or ceilings. The results were radically new vistas that effectively reimagined the urban environment. But Matta-Clark conceived his artistic project in even broader terms. *Fake Estates*, for example, took on the essence of the American dream of land ownership and involved the purchase of interstitial, and hence unusable, sites across Manhattan. *Food*, by contrast, was an eminently social enterprise that turned communal interaction itself into an art form. Matta-Clark ran the SoHo venue—part restaurant, part performance piece—from 1971 to 1973. Like so much of his work, it now appears positively prescient. When Rirkrit Tiravanija cooks Pad Thai as art these days, that quintessential gesture of relational aesthetics seems to come straight out of Matta-Clark's kitchen.

None of this makes the work easy to display, however. The startling subversion and stunning elegance of the building cuts can only be gleaned, and imperfectly at that, from photographs. Other projects are preserved only on grainy film or even grainier video, and much of the work requires extensive textual explication. The only real eye-catchers are the pieces salvaged from some of the carvings. They may not look like conventional sculptures. But as rough building fragments, they titillate with the mystery that often attends the radical displacement of eminently familiar objects. They are also exceedingly delicate, presenting the vexing conservation issues often found in "non-traditional" art objects.

Still, the show is a no-brainer for the MCA. The institution has a tremendous stake in Matta-Clark's legacy. Its 1978 invitation to undertake a building cut in the museum's annex-to-be produced the artist's first solo show at an American museum. And his sudden death just weeks after the exhibit ensured that it would remain the only one during his lifetime. A few years later, moreover, the MCA organized Matta-Clark's first retrospective, an ambitious survey that opened in 1985 and traveled to over a dozen European and North American venues.

The present exhibit does not originate at the MCA. *Gordon Matta-Clark: "You Are the Measure"* was created at the Whitney Museum, where it debuted in early 2007. But it's the first major American retrospective since the one from the mid-1980s, and that makes the new MCA a natural stop. It even gets the star treatment, occupying all of the museum's main galleries on the second floor (where it will be followed by Jeff Koons). The exhibit also contains extensive material that is exclusive to the Chicago presentation. Much of it, never seen before, pertains to the pioneering 1978 building cut—a piece with a misleadingly kid-friendly title: *Circus*.

But children, even very little ones, are certain to be around the Matta-Clark show. The MCA's Family Days assure as much. They are held on the second Saturday of each month, a fixture on the calendars of Chicago's kidded sophisticates. Like other civic institutions competing for parental attention, the MCA goes all out for these occasions. The entire museum is transformed, with activity stations placed on every level and staffed by a crew of what the institution refers to as *teaching artists*. Each Family Day is loosely themed, but there always is a slew of options "appropriate for all ages." Even admission is free, provided you are a family with children under the age of twelve.

"You Are the Measure" opens thirty years to the day after the completion of *Circus*. That's Saturday, February 2, 2008. A week later, it's Family Day. The theme is "I Heart Art," and some of the activities are cued to Valentine's Day. Kids can "Love like Calder!" by creating "heart mobiles" that "place your family and friends in a web of love." Alternatively, they can learn to make "Sweet Petals" for their "sweetheart," a "fantastic bouquet of flowers using your favorite candy."

But *"You Are the Measure"* is invoked too, and the kids are encouraged to "take a peep at our new show where artist Gordon Matta-Clark

makes trash into treasure and cuts buildings in two." The trope of magician-cum-superhero is even carried into the day's activities. In the second floor atrium, immediately adjacent to the various chunks Matta-Clark extracted from buildings during the 1970s, children can follow the artist by creating "musical instruments out of recycled materials."

Which brings me back to that stunned moment of silence during the staff tour. To be sure, the MCA has "Road Rules" for Family Days, which make it clear that children are not to run around or touch the art. But evidently, kids will be kids, especially when confronted with objects as intriguing as Matta-Clark's building fragments. And with that, the curator resolves to take action. Still pale, she finally sighs, "For the next Family Day, we will have to close off the piece with additional protection."

The irony is not lost on me. The education department tries so hard to activate the MCA as a place for play. And just when an exhibit offers opportunities for real adventure, the would-be jungle gym has to be shut down.

~ ~ ~

Meanwhile, the *Made in Heaven* issue I first registered in early January has continued unabated into February. With inconclusive communications from Koons and no resolution in sight, worries abound. In meeting after meeting, I hear that there is an urgent need to convey the MCA's "institutional perspective" to the artist. Finally, it is resolved to send a high-level delegation to Koons's New York studio. A personal entreaty, it is hoped, can communicate the museum's "point of view."

The visit takes place in mid-February, and the results are cause for celebration in the education department and beyond. The meeting, it turns out, is a total success. Just minutes after leaving the studio, the MCA folks send the troops back home an e-mail that cuts right to the chase: "Jeff Koons agrees to segregate the Made in Heaven series." The development department, it goes on, can proceed to assure the corporate sponsor.

Over the next few days, the conversation with Koons is the topic of several meetings back at the museum. The mood couldn't be better, and the story of New York is gladly retold a number of times. Evidently, the get-together at his studio was the first opportunity Koons had to *really*

focus on the MCA show. And while he is still keen on an open floor plan that can bring his various series into conversation with one another, he is perfectly amenable to isolating *Made in Heaven*. "He has kids, so he understands," one of the delegates assures the rest of the staff, although a few weeks later it is learned that he just took them to see the Gustave Courbet show at the Metropolitan Museum, *Origin of the World* and all. But no matter. What's important right now is the realization that "Jeff is quite open." "He is an artist who understands what we are doing."

Then, all of a sudden, a comment out of left field. "The concerns for *Made in Heaven* are misguided," one of the curators says with a glint, "the lobsters are far more pornographic." I am startled. Pornographic? The lobsters? They are ubiquitous in Koons's work, appearing in paintings and sculptures, including several that will be in the MCA show. As I learn, Koons uses them as an overtly phallic symbol, refracted through a complex chain of references that also involves the imagery of Salvador Dalí. "And teapots, too—those have to do with bodily orifices. Really, if you start dissecting Koons's work, you quickly get into trouble."

I get apprehensive. Is this another issue? As I look around, however, I realize that no one else in the room is the least bit discomfited. In fact, the various staff members in attendance—educators, marketers, fund-raisers—barely respond to the explication of Koons's sexual typology. Finally, one of them simply puts an end to the conversation: "The *Made in Heaven* series really was the only thing that was problematic."

I think about that moment for a long time. And in the end, I begin to understand the response, or lack thereof, by the non-curatorial staff. From their vantage point, the metaphors in Koons's pieces are really quite secondary. What matters is what's in front of you and, particularly for the museum educators, how audiences will respond to it. Koons may think of his lobsters and teapots as the carnal counterparts to the innocent meditation on connubial bliss that is *Made in Heaven*. But for a museum that, as one staffer puts it, "respects the artist, but also respects the need for the visitors to have a good experience," those are minor subtleties of authorial intent.

Indeed, when the Koons show opens, none of the accompanying material explicates the artist's sexual symbolism. In today's contemporary art museum, sometimes a lobster is just a lobster.

But what about a couple canoodling on the floor in a series of suggestive poses? For the curators, it may well be an original aesthetic gesture. For the educators, it more likely is a cause for pubescent damage control. Welcome to Tino Sehgal at the MCA!

It's the end of 2007. And the museum couldn't be presenting a hotter show. For the last few years, Sehgal has been tearing up the biennial circuit. His presentations in Venice (2005) and Berlin (2006) were international sensations, adulated by visitors and art press alike. But with several impressive European solos already to his credit—including London's ICA, Amsterdam's Stedelijk, and Hamburg's Kunstverein—he has yet to show at an American museum.

This has a lot to do with the nature and condition of his oeuvre. Sehgal does not present conventional artworks, not even objects. Instead, his pieces are "constructed situations" in which "interpreters" perform his scenarios and scripts, often in dialogue with the audience. Many of them cleverly mock the art world, including his contribution to the Venice Biennale, in which the entry of a visitor prompted three security guards to jump around ecstatically and chant, "This is so contemporary, contemporary, contemporary!"

So the work is pretty spectacular. But what adds even greater intrigue is Sehgal's uncompromising vision. Trained in dance and economics, he sees his work as a wholesale critique of materiality, for which he substitutes an experiential aesthetic grounded purely in the here-and-now. In practice, this means that Sehgal strictly disallows the production of any and all *things* in conjunction with his work. There are no photos, no films, no catalogues, not even wall labels—just his interpreters. Those, he insists, have to be trained by himself, a very involved undertaking given the specificity of his constructed situations. Oh, and he refuses to fly.

For the MCA, it's a huge coup to present Sehgal's first show at a U.S. institution, not least because the demand is so great. After Chicago, the artist will be featured at the Walker Art Center in Minneapolis, the Wattis Institute for Contemporary Arts in San Francisco, and, in 2010, the Guggenheim. His piece *The Progress*, in which increasingly older inter-

preters involve visitors in conversation as they ascend the spiral ramp, becomes one of the most talked-about cultural events of the decade.

Encountering a piece by Sehgal, especially for the first time, is, in fact, quite magical. I, myself, fell under the spell in Berlin. The 2006 biennial there was a riveting affair conducted on Auguststraße, a storied address in the former East Berlin and home to Kunst-Werke, the united city's first address for cutting-edge art. Most of the work was right there or across the street in a former Jewish girls school, one of the more indelible places to see contemporary art. But a few displays were at other sites on the long artery. As I made my way, I came upon one of them: the Ballhaus, erstwhile one of Berlin's prime destinations for urban amusement, but now a derelict structure. I walked into the nearly dark building and followed a beam of light that seemed to point upstairs. All of a sudden, I was in a ballroom, its dilapidated splendor right out of a Fellini film. One other visitor was there, her gaze intently fixed on the middle of the room. She was looking at a couple on the floor. They were moving in slow motion, specks of light hitting them periodically, from one pose to the next—a mesmerizing *tableau vivant*.

What I encountered in Berlin was *Kiss*, one of Sehgal's signature works. In the piece, two dancers, a man and a woman dressed in casual clothes, enact some of art history's iconic instances of osculation. There is Rodin, Klimt, and Brancusi—and, for good measure, Jeff Koons and Cicciolina.

Kiss is also the piece presented at the MCA. And while the setting couldn't be more different, the effect is no less enthralling. Much like in Berlin, visitors just happen on the work, in this case in the middle of the galleries. There is no immediate explanation (no wall labels, remember?)—just a confrontation with some pretty radical propositions on the nature of art, performance, and objecthood.

Or it's just a guy and a girl making out in the middle of a museum. That, in fact, might well be your inference if you visit the MCA on a school trip with your fellow ninth graders. And if that is the situation, you may well forgo this excellent opportunity to ponder the ontology of the artwork in the age of dematerialization. Instead, you might say something like "Whoa!" and proceed to laugh nervously while your friends

are cracking up all around you. At that point, the pressure is on your tour guide—at the MCA, this would be one of the teaching artists who also staff the activity stations on Family Day. Ideally, they should utter something profound. But if they follow prevailing educational principles, they will, first and foremost, attempt to validate your adolescent response. "It's perfectly all right," they might say, "if this makes you feel uncomfortable." And move on.

Scenes like this happen at museums every day. What's different about the Sehgal show is that the art can hear it all. And when the interpreters report back that this scenario plays itself out day after day, not every curator is pleased.

~ ~ ~

But what *is* the appropriate response to contemporary art? And what are its lessons, particularly for a younger audience?

To earlier generations of art professionals, the answers would have been pretty straightforward. Modernism, after all, provides a template both for the production and consumption of the avant-garde. As an autonomous formation, its trajectory needs to be understood, first and foremost, on its own terms of ineluctable aesthetic progress. This, of course, is the lesson of Alfred Barr's diagram, with Van Gogh begetting Fauvism, Fauvism begetting Abstract Expressionism, Abstract Expressionism begetting Non-Geometrical Abstract Art, and so on.

This pure model of *l'art pour l'art* has long since collapsed. But it bears noting how implausible it has always been in light of America's educational realities. Given the essential absence of art history from school curriculums, student groups were never in a position to cogitate on the internal history of modern art. Museum educators are obviously aware of this. As keen observers of schools, they know what teachers do in and out of the classroom and understand how a contemporary art institution might figure in their pedagogy. Formalism, in other words, won't do the trick.

The mantra that results from all this is hardly unique to the MCA: "Contemporary art is a great way to talk about *social issues*." And what this means in practice can be gleaned from the extensive material the

education department provides to teachers. At its core is the explication of twenty-two pieces from the permanent collection. The conceit is ingenious. With portions of the museum's inventory always on display in the frequently rotating exhibitions drawn from the museum's holdings, visiting educators are guaranteed to find teachable artworks. To further aid their task, the pieces are organized into curricular clusters, categorized by grade levels, and furnished with lesson plans. A print by Barbara Kruger, for example, is offered up as an ideal vehicle to reflect on "advertising and the media in society" (grades 7 to 12), while a Kara Walker installation is presented as an occasion for the study of slave narratives (grades 9 to 12). Social studies and language arts are consistently foregrounded, and all but four of the twenty-two pieces speak to such issues as "Exploring Identity," "Representing Our World," or the "Power of Words."

What is most striking, however, is the emphasis on students' experience and involvement. Take Cindy Sherman. The piece the educators focus on is from her early 1980s *Fashion Series*, showing the artist with tussled hair and a slumberous look and wearing a large red robe. The accompanying description does relate the work to the preceding *Untitled Film Stills*. But the art historical context is light; appropriation and feminism are not mentioned. What students *are* enjoined to learn is "how alterations to appearance (clothes, hair, makeup)" affect "our perception of one's identity or suggest a narrative." And it's learning by doing. The lesson plan—for art and language arts classes, grades 5 to 8—suggests a discussion of the "choices the artist has made to create a certain mood or personality," followed by the composition of dialogues Sherman's figures might have with one another, and culminating in the creation of the students' own Shermanesque characters.

The sensibility is similar in the case of Felix Gonzalez-Torres and his work *Untitled (The End)*, one of the artist's infinitely renewable paper stacks, this one blank save for a black edge. There, too, the emphasis is on activating the students. Following Gonzalez-Torres's example, they are encouraged to "create a 'stack' of some inexpensive material that they can give away." But that's not all the artist is good to teach with. For language arts, students can write essays "about what they did with the pieces from the class stacks," while a social studies lesson could focus on

Gonzalez-Torres's attempts to "stimulate social consciousness regarding issues, particularly problems and injustices, of contemporary life." Even math teachers can get in on the action: "If a stack created by Gonzalez-Torres in the museum has 300 sheets of paper, and if 225 people come to see his show and a third of those take a sheet of paper away with them, then how many sheets are left in the stack?"

A cynic might inveigh that a highly polyvalent piece of post-minimalist art is not the most obvious occasion for a math problem. But as a museum educator, you go to teachers with the objects you have, not the ones you might want or wish to have. If that's contemporary art, so be it. The fish at the Shedd Aquarium would be so much easier, though . . .

~ ~ ~

It is safe to say that the MCA will keep at it, trying to come up with ever new and creative ways to attract Chicago's youth. It simply has to. This is not to say that its educators don't believe in the cause. On the contrary, they are dedicated professionals who fully trust in contemporary art's power to open young minds to the world. But even if that were not the case, the museum would strive to engage the young. Funders demand no less. Corporations, foundations, state agencies—they all want to be in the business of bringing up the next generation.

Target, the giant retailer, is one of them. Its corporate philosophy prizes the arts as a way to secure a "bright future for us all." And as a partner of "passionate organizations" seeking "to ensure that kids in your community get the opportunity to shine," the company has sponsored the MCA's Family Days for several years.

It's not easy for the museum, though, as I happen to know firsthand. From 2003 to 2011, I sat on the board of directors of the Illinois Humanities Council. It's your standard nonprofit, dedicated to doing good things in the world, in this case "fostering a culture in which the humanities are a vital part of the lives of individuals and communities." It also happens to be federally mandated and partially funded by the National Endowment for the Humanities, just like its counterparts in the forty-nine other states. In addition, it receives funding from the State of Illinois, numerous foundations, and countless individuals.

Twice a year, the Council accepts grant applications from Illinois's

cultural organizations. The criteria are clear. Funds go to those institutions that demonstrate the greatest ability to reach deserving populations. The state's children are always at the top of the list, often in conjunction with considerations of socioeconomic and racial inequities.

The MCA sends an application for every funding cycle. They always have a project that could benefit from the support of the Council, and so does every other major institution in the state. Long before I come to the museum as a researcher, I was its champion during the biannual competitions. But it was tough to convince my fellow board members that supporting, say, the activities surrounding Francesco Bonami's latest curatorial extravaganza was the best use of the Council's limited means. Wouldn't that literacy initiative on the South Side of Chicago be a better way to reach underserved children? Probably, I used to think to myself, as proposal after proposal went down in flames.

~ ~ ~

I've been at the Jeff Koons opening for over an hour. After a quick stroll through the galleries, I hover around the buffet, taking in the scene and chatting with the museum staff. Everyone is beaming. The months of work and worry have paid off. The show is a smash.

Then it hits me. Where are the *Made in Heaven* paintings? I rush back. Nothing in the southern gallery; the lobster hanging from the ceiling doesn't count. Back to the northern one. Nothing there either, just oodles of colorful sculptures surrounded by colorful paintings (with, yes, more lobsters).

Finally, I see what's going on. At the end of the northern gallery, there is a makeshift wall. From the entrance it's barely visible, seamlessly blending into the exhibition's open layout. On approaching, I realize how closely the barrier is set to the actual wall, resulting in a narrow corridor. A museum guard is right there, nodding unobtrusively at the posted sign. It says that parts of the show are inappropriate for younger visitors.

I enter the passageway. The effect is stark. *Made in Heaven* may be sequestered. But when you do come face to face with it, the scale is stifling. With no room to step back, the three vast canvases don't resolve into full images. Instead, they arrest the viewer's gaze and fix it on the anatomical details.

Leaving the corridor, I realize that no one around me seems the least bit perturbed by the explicit images. Maybe the MCA didn't have to be quite so fearful after all, I think for a moment. Then I remember that the corporate sponsor never did sign up. And as I take one final look at *Ilona's Asshole*, I can't quite believe it's hanging in the museum at all.

THE GIFT 4

Is the work a subtle critique of the commodity form in late capitalism or merely a hysterical enactment of its worst excesses? The debate has been raging among observers ever since Jeff Koons stormed onto the contemporary art scene in the 1980s, that decade of *greed is good*. Initially, there was some inclination to see his efforts as a critical commentary on the "artist's role as producer of luxury items" (Roberta Smith in 1986). Quickly, however, he came to be regarded as complicit with a "consumer society in which the moment is everything," producing "art that proudly advertises itself as a commodity" (Michael Brenson, Smith's then-colleague at the *New York Times*, in 1988). That reading of Koons has since predominated, although there are those, like Hal Foster, who continue to assert subversive potential on account of the fact that "the connoisseur of the art work is positioned as a fetishist of the commodity-sign."

I, myself, am put in mind of Slavoj Žižek when contemplating Koons's stance on capitalism. The Slovenian philosopher and cultural critic, famously fond of paradoxes, likes to assert that the most profound form of

resistance is the wholehearted adoption of the reigning ideology. Seen in this light, Koons's unconditional surrender to the marketplace is both celebration *and* subversion. Ah, the joys of criticism—you get to have your cake and eat it too.

The MCA doesn't have the same luxury of ruminating on academic ambiguities. It operates in the actually existing art world, where the facts are pretty straightforward. Resistive or not, Koons's works are among the most rarefied, sought-after, and expensive things in the world. And to get them to Chicago requires the active collaboration of their *owners.*

This is quite different from, say, the Jenny Holzer show. There, a number of pieces are being lent by collectors, but the bulk of the work is supplied by the artist's galleries. The pieces, in other words, are not yet sold, and for Cheim & Read (New York), Yvon Lambert (Paris), and Sprüth Magers (Berlin and London), the MCA exhibit is an excellent vehicle to boost Holzer's reputation, showcase her work, and attract potential customers.

Not so in the case of Koons. He, too, is represented by galleries—Max Hetzler (Berlin), Sonnabend (New York), and Gagosian (with franchises around the globe). But those outfits are not exactly sitting on inventory, particularly of the kind needed for a career-spanning retrospective. Whenever Koons's work does become available, it tends to sell like the hotcakes it might depict—and to selected clients who have typically endured years of pining on a waiting list. That's if collectors aren't paying for the privilege of fabricating the work in the first place. Koons's most iconic (and largest) pieces have come into being that way, ordered up for a small cadre of collectors and produced to the artist's exacting specifications in five different colors. *Balloon Dog*, for example, exists in blue, magenta, yellow, orange, and red—all of them unique and, with their exclusivity, virtually priceless.

So the MCA is looking at an extraordinary task of persuasion. Some of the world's leading collectors need to be ensorcelled to part with some of their most prized possessions. And then, the museum must find the money to get the stuff to Chicago.

~ ~ ~

The MCA's dependency on patrons is par for the course. Every American museum, every nonprofit really, relies on the mobilization of individual

donors to support its efforts. But what this means in practice has been changing over the last thirty years, both at the MCA and at contemporary art museums generally.

The expansion of institutions is the most immediate reason. Burgeoning staffs and elevated operating costs produce an ever-growing need for cash flow. To meet it, development activities are bulked up continuously. While I'm at the MCA, fundraisers outnumber staffers of any other stripe. The development department alone counts ten members (compared to the seven in curatorial, for example), with numerous individuals in other units centrally engaged in fundraising efforts as well.

And operations are becoming ever more complex. Consider the phenomenon of tiered memberships. The most basic form of fundraising—originally intended to create the broadest possible pool of museum supporters—it has become a baroque system of ranks, perks, and privileges. By my count, the MCA offers fourteen different categories, all of them carefully delineated by price and benefits. Within the class of *Premier Memberships* for example, you can be a *Friend* ($150 a year), which, in addition to free admission and discounts at the café and bookstore, gets you a complimentary individual gift membership as well as "six free guest passes for your friends—a $72 value!" Become a *Contributor* ($250) and you get all of the above and an evening reception with a curator. As an *Associate* ($500), it's all that and an invitation to an artist reception, etc., etc.

The logistical efforts associated with this kind of complexity are considerable. At the MCA, several staff members are tasked with making the different levels of membership meaningful by scheduling events of staggered exclusivity. Openings are a prime case in point. Jeff Koons, for example, ends up with a triple. A vernissage for *Circle Donors* ($1,500 and up) takes place on Thursday, followed by the member opening on Friday, and the invitation of the general public on Saturday. Yet other staffers have to prevent slipups in the system. Members monitor their promised perks carefully and might not be pleased if they don't come through or, worse, are mistakenly extended to lower categories. Lest all this seem excessive, one need only to remember that individual donations—from basic memberships to board contributions—make up half of all the funds raised annually by the MCA, a development model much like that of its peer institutions.

No matter how innovative or aggressive a museum's fundraising efforts, though, it will always hobble behind financially. The main reason is the contemporary art market—a slice of the economy that has been subject to a stunning transmutation over the last few decades. Quite simply, there used to be no such thing. Artists have always been creating, of course, and with the emergence of modern art, the gallery system as we know it did come into existence. But until well into the late twentieth century, contemporary art was seen as anything but a commodity. Art, the conventional wisdom held, had to prove its value over time, rendering product that was fresh off the easel essentially worthless.

How times have changed. As breathless headlines report on a daily basis, we are in the midst of a contemporary art boom that makes prior moments of irrational exuberance (the late 1960s, the early '80s) appear like little boomlets. It's the auctions that draw the greatest attention. They have become a veritable spectator sport, with fearless bidders duking it out in the halls of Christie's and Sotheby's, all of it broadcast live on the Internet and chronicled in doting reportage from the *New York Times* to the blogosphere. The old rules, meanwhile, have been thrown out the window. Historical validation is no longer a prerequisite for entering the marketplace, as even brand-new work is snatched up for record prices—and not only when it's made by Damien Hirst's studio assistants. But the auctions are just the tip of the diamond-studded iceberg. The prices for contemporary art have been escalating in general. Even an artist's first gallery outing can retail in the five-figure range, particularly when the right art school credentials are involved (that would be Columbia or Yale). And it doesn't take much recognition for the next digits to be added.

Ebullience may be swirling all around. But for an institution like the MCA, the boom is a real bummer. Take something as unglamorous as insurance. It used to be that premiums were negligible. Showing things with little monetary value, after all, hardly required extensive coverage. With the spectacular commodification of contemporary art, all this has changed. Jeff Koons's first MCA show in 1988 was an early touchstone, with the art on display valued in the hundreds of thousands of dollars—unprecedented amounts whose attendant premiums probably surprised

the museum's accountants. But how quaint by the standards of two decades hence, when mounting insurance costs weigh heavily on the institution. Small wonder—the wares in the 2008 Koons exhibit total in the hundreds of *millions*.

To say nothing of actually *buying* art for the MCA. There, the boom is effectively pricing the museum out of the action. Now, it should be noted that the MCA never went on wild shopping sprees on behalf of its permanent collection. Like most of its counterparts, it has acquired the bulk of its holdings through donations, primarily from board members. But in the old days, the financial context was much less forbidding—it just didn't take a whole lot of money to reach into the art market. Today it does, making almost all collecting a function of gifting.

~ ~ ~

I'm in the fifth floor conference room, sitting in on the weekly meeting of the curatorial department. Things are exceedingly informal, as is always the case when the curators are among themselves. There is some talk about exhibition schedules. Soon the conversation moves on to the main topic for the day: the Collectors Forum. Over the coming months, the group will make its annual choice of a work for the MCA's permanent collection. It's an elaborate process that involves numerous gatherings and huge amounts of research. The plan is to start with a list of ten artists, narrow it down to six, and finally arrive at three whose pieces will be put on display in the museum's galleries. The final vote is scheduled for a banquet in late May, more than four months from now.

None of this is unusual. Every contemporary art museum sponsors associations of this kind. They all charge membership dues, which are typically divided between an institution's general operating fund and the group's acquisitions budget. A standard pot is in the tens of thousands—small potatoes by Koonsian standards, but real money nonetheless.

I am instantly fascinated by the Collectors Forum, not least because it distills the dynamics of donorship to its conflicted essence. The basic tension is already built into the administrative setup. Much like its analogues at other institutions, the group is jointly run by the MCA's curatorial and development departments, two units whose modes of op-

eration are, to put it gently, not necessarily congruent. For the curators, the Forum is an opportunity to mold the collection in the absence of a flush acquisitions budget. For the fundraisers, it is a chance to get donors excited by giving them a stake in the museum's enterprise. This is particularly relevant for the class of patrons involved in the Forum. At a few thousand dollars in annual fees, they are not among the museum's top donors (those would be folks giving in the tens of thousands). But they are in the 20 percent of benefactors who account for 80 percent of contributions. So while their level of support may not translate into a seat on the board of trustees, they do represent a vital constituency.

And one whose voices need to be heard. This starts with the initial selection process. An entire list has been culled from Forum members' proposals. As I hear the name of one star after another, I am instantly transported back to when I last walked the aisles of Art Basel Miami. A number of the artists elicit curatorial approval; others are greeted with considerable skepticism. The ready consensus is that the MCA needs to acquire "museum-quality work." Under no circumstances can the institution succumb to "art fair fever."

With that, the conversation moves on to a list of artists generated by the curators. At first I'm perplexed. The names I hear now are no less trendy than the Forum's favorites, and it occurs to me that their main virtue might simply lie in the fact that they were chosen by the curators instead of the collectors. I never fully abandon that interpretation. But as I think about it some more, I *do* see certain patterns in the selections. While the artists fancied by the Collectors Forum tend to work on relatively small scales and in two dimensions, the curators favor creators of complex installations that often involve multimedia elements. There is also an art historical component, with the curators preferring artists who self-consciously position their output vis-à-vis various traditions.

To the curators, though, the difference between the two sets is self-evident, and much of the meeting is spent strategizing about ways to guide the Forum. "They need to understand what we need," one of them says, "real substance, real relevance, something that relates to our collection." It is resolved that the next assembly of the Forum will commence with a disquisition on the MCA's aesthetic values. "We have to remind them about the level of work we have bought in the past."

It used to be so different. At least, that's the gist of the stories I hear from old-timers, and not just at the MCA. Donors got involved out of civic responsibility and the earnest desire to bring the best art to Chicago. It was never about the hunt for the latest art star.

I'm skeptical. The past gets transfigured all too easily, becoming everything an encumbered present is not. The MCA's archive bears this out. No rose-colored building there. Instead, it reveals an institution completely dependent on its donors and run by a very hands-on board. It could not have been otherwise for a startup of the '60s and '70s.

And yet, the nostalgia is not without *some* factual basis. In many ways, for example, the support of donors during the founding years *was* disinterested. Not that they didn't care about the MCA. But their involvement was often unrelated to their own aesthetic predilections. Sure, they were art lovers, even collectors. Only a few, however, acquired contemporary art. A preference for modern masters or non-Western art was much more common.

But there was disinterest even among backers who *did* collect the art of their own era—at least in financial terms. This was simply a function of external realities. When the MCA was founded, contemporary art was only beginning to attain commodity status. By today's standards, it was still laughably cheap, with major pieces by prominent living artists obtainable for a few thousand dollars. Even more importantly, the notion of contemporary art as an investment was totally absent. Collectors bought work to feel part of a cultural vanguard and support its creators. Doing it to turn a profit was utterly implausible.

There is a widespread sense that this has changed completely. Indeed, the collector-as-speculator, with Charles Saatchi as the bellwether of the species, seems everywhere nowadays. His flock extends even to sleepy Chicago, where you can readily find folks who pride themselves on running hedge funds with contemporary art. They scour the market for "undervalued" artists, buy their work in bulk, put it in storage, and wait for the opportune moment to cash in. With the continuous escalation in prices, this can be quite lucrative. At least that's what they tell me.

So, yes, the speculators exist. But in reality they make up a small

percentage of contemporary art buyers. For the majority, collecting continues to have no overt profit motive. It is still done by people who, for some reason or other, fall under the spell of the latest art, attracted by its strangeness and beauty and hooked by the glamorous world of its creation. Billy and I, in other words, are pretty typical.

And yet, the collector's experience has been transformed profoundly. It has to do with money, naturally. But not just the obvious stuff: Billy and I pining for art we will never be able to afford. At stake, rather, is the logic of commodification itself, the fact that the acquisition of contemporary art—rather than a quirky form of conspicuous consumption—has become synonymous with the accumulation of assets, whether or not you're planning to sell them at a profit. This is why encounters between collectors almost invariably devolve into ritualized exchanges of portfolios. As artists are rattled off like stocks, the emphasis is on important pieces that were "bought low." In the age of an all-pervasive market, it is the ultimate form of connoisseurship, investing in work before its worth is recognized. One doesn't have to be a speculator to see contemporary art collecting in those terms. It's built into the system.

I know of what I speak. Billy and I have never "flipped" a piece and have no intention of doing so. But ask me about the current value of any work in our collection, and I can give you a pretty good indication. Like many of my ilk, I follow these things closely, after all. And I take extraordinary pleasure whenever an artist whose work we own moves up to the next financial plateau. In a thoroughly postmodern art world, ever expanding and characterized by near aleatoric aesthetic pluralism, it is the one universal metric available.

There are any number of contributing factors for such a leap, from write-ups in the right publications to purchases by the right collectors. The surest way by far, though, is an artist's exhibition in the right museums and, even better, incorporation into their collections. And this is where the feedback loop kicks in. With the value of art centrally dependent on institutional acceptance, what we get is the unprecedented financial incentivization of museum patronage.

This phenomenon is unique to the field of contemporary art. Think about it. When the Art Institute showcases its collection of early modern tapestries, to take a random example from the 2008 season, the display is

not likely to upend the market value of such artifacts. Sure, there might be a temporary bump on account of a rise in interest. But with historical import and aesthetic judgment pretty set, an eventual return to the baseline can be expected. The same is true for just about every other variety of canonized art. The presentation of Italian Renaissance and Baroque drawings by Chicago collectors Jean and Steven Goldman, held at the same time as the tapestry showcase, may well have been linked to their long-standing support of the Art Institute. But it does not significantly enhance the value of their holdings, nor does it fundamentally alter the market for European master drawings.

This is altogether different in the realm of the contemporary. There, museum exposure doesn't just affect an artist's market. It often *creates* it in the first place. The MCA might not be the most powerful institution in this regard (that would be MoMA, of course). But there are plenty of examples that evince the museum's ability to produce a commercial juggernaut. John Currin comes to mind, whose 2003 show turned him into the world's hottest painter and his canvases, their eerie Mannerism notwithstanding, into some of the most sought-after wall decorations around. In 2007, the same happened with Rudolf Stingel, who morphed from high-end conceptualist to auction darling within the span of a few months. Both exhibits traveled from the MCA to the Whitney, where they were critical and popular triumphs. And ever since, the two artists command prices in the hundreds of thousands of dollars.

To say that patrons are aware of such dynamics is a colossal understatement. It orients just about everything they do, whether as collectors or benefactors. As buyers, they have every reason to acquire work that has been or, better yet, is about to be shown at an institution like the MCA. And as donors, they have every incentive to get work they own (or, at least, the work of artists whose work they own) into the museum. It's as simple as that.

~ ~ ~

I'm back in the conference room. Three weeks have passed since the curators went over the list of names for the Collectors Forum. Since then, countless hours have been spent investigating the various artists, ascertaining available works, and initiating conversations with their galleries

about prices. And now it's time for the big reveal: the members of the Forum have assembled to learn the identities of the ten artists under consideration and select the six who will make it to the next round.

Actually, they are not quite here *yet*. It's 5:03 pm and only six of the fifteen expected to be in attendance have trudged in from the snow. Staff meetings never start on time, the chatty banter going for ten minutes or more while folks settle in. But this is different, much more formal. Everyone is sitting upright, and the pleasantries are perfunctory. At 5:05 pm, half the group is still absent. But the meeting commences nonetheless. This is serious business, the professional mien suggests, no time for dawdling.

I have been anticipating the moment with considerable excitement. Weren't the curators going to explicate the MCA's aesthetic principles? A formal statement along such lines would be like coming upon the holy grail. But it's not to be. What I see instead is a slide show of the Collectors Forum's previous acquisitions. "This group has done great!" one of the two curators at the meeting enthuses as countless images flicker across the screen. I look around. Nods of recognition as pieces by Beat Streuli, T. J. Wilcox, Gillian Wearing, and Carlos Amorales, among others, stray into view. Those were "really important additions," the curator explains, "iconic work" that "will stand the test of time."

As I sit there, I wonder what makes these pieces iconic. But there's no time to puzzle it out. "Thank you so much for all your help," the exposition concludes—and it's on to the other curator for the presentation of the ten artists.

The pace is brisk, the aesthetic diverse—low-tech installation competes with vaguely figurative painting, conceptual photography with sculptural experimentation. It's a good illustration of current style by a group of artists comfortably lodged between late emergence and early stardom. There's much talk about participation in biennials (Whitney to Venice), acquisition by major museums (MoMA, anyone?), and representation by top galleries (preferably those with cross-continental reach). And yes, art fairs come up, too.

Throughout the presentation, the Forum members ask sensible questions. Often the issues are logistical. How would a certain piece be conserved given that it's made of perishable materials? What would be the

mode of display for a three-dimensional work that can be experienced from multiple, and rather distinct, vantage points? Money comes up as well. Turns out, some of the pieces under consideration are surprisingly affordable. Can the work be that good then, the collectors inquire? Absolutely, the curators aver. It's a rare moment when the art market's grip seems to loosen just a bit.

After an hour of exposition, everyone's ready to get to the fun part— the casting of ballots. The process is explained, and as I listen to the rules, I realize that it falls somewhere between *American Idol* and the old Chicago adage to vote early and often. The collectors can choose any of the artists they want; they can vote for all of them or none of them, or some number in between.

A few minutes later, we have some results: three artists are out of the running. But that still leaves seven artists against the desired six, and the next two are tied in the count. Confusion ensues when a runoff reaffirms the original ballot. Amidst proposed vote changes and calls for a repeat of the entire process, one of the curators steps in and suggests, to everyone's palpable relief, that the Forum could simply move seven candidates to the next round. But sensing an opportunity regarding the near elimination of one of the bargain pieces, she reminds the group that "if someone loves the work and wants to give it to us, let's talk!"

~ ~ ~

It was only a few months prior that Billy and I were ourselves cultivated as potential donors. It wasn't the MCA, but it might as well have been. Not that I even fully realized what was going on at the time.

By art world standards, we are small fish, with neither the money nor the collection to make a real institutional difference. So when one of the city's young curators expressed interest in coming to our apartment, I didn't put two and two together. I was just giddy with the prospect of showing off our prized possessions. This is what all collectors ache to do, no matter what they claim, having their efforts validated by the interested gaze of a third party. That said, it's always a bit unnerving, even awkward, to show one's stuff to a fellow collector. In a way, it's a lose-lose proposition. If your visitor (let's say he is male), collects similar work, he becomes an immediate rival. Does he have a better piece by Walid Raad,

you nervously try to ascertain, and did he buy it lower? But that's still better than realizing that your collections have nothing in common. Implicitly at least, that's a pretty damning critique of what you're up to, since your aesthetic (and where you're putting your money) so obviously falls short of your guest's standards. *Really*, you collect political art? That's, um, so *admirable*."

Not so with curators. They're not in the sport of competitive collecting. The vow of poverty imposed on them by the art world ensures as much (along with various ethics codes). But like a soccer referee who is paid a pittance yet gets to influence, even decide, the outcome of a game played by millionaires, they are empowered to arbitrate the maneuvers on the artistic field. Theirs, after all, is the imprimatur of the museum, the very manifestation of relevance and canonicity. What, then, could be more exciting for a collector than to receive one of these keepers of art history in one's home to pronounce, hopefully with approval, on one's choices? As I said, I was thrilled.

I immediately started to make plans, thinking that a nice, leisurely weekend brunch would create the perfect ambience for the visit. I should have realized my bad judgment when the curator balked at the proposed date, suggesting a weekday afternoon instead. But I persisted, wanting so badly for this to be a lovely social occasion as well. Not even the fact that the curator's husband refused to join us—"he doesn't like these kinds of things," she said—gave me a clue.

In many ways, the visit turned out to be a great success. The eggs came out just right, and the curator said all the things I was hoping to hear. She asked penetrating questions about the way Billy and I decide on acquisitions, shared her thoughts on a number of the artists in our collection, and complimented us on many of our pieces. She even suggested that we make our home available for a tour with supporters of her own institution, something that did, in fact, happen a few months later.

Even as the brunch was going on, though, my mistake began to dawn on me. Sure, everyone has to eat, and the pastries were especially delicious. But this was not a pleasure visit. The curator was at our apartment to do her job, and I made her work on Saturday.

It dawned that day. But it has become fully clear seeing up-close what the MCA's curators actually *do* for much of the time. Not only is their

work made possible by contributors—that's true of all nonprofit organizations—but it's work that needs to be done *with* them. That's why every encounter with a patron is always already part of the job. When curators interact with a collector, they see a potential donor of art (either from their collection or bought for the museum outright), a potential supporter of shows (either by lending pieces or by helping to defray exhibition expenses), or a potential backer of a more general kind (either as a high-level member or as an underwriter of special initiatives). If this sounds calculated, even mercenary, it really shouldn't. It's simply built into a structure in which everything a contemporary art curator does presupposes the active support of benefactors.

At the MCA, I see what this means in practice: heaps of time spent with collectors. There are board committees to prepare, luncheons to attend, gifts to steward, donors to tour around the museum, art fairs to navigate, and, of course, the Collectors Forum to shepherd through months and months of deliberations.

But somehow, it's never quite enough. Couldn't the curators make a couple of additional phone calls, visit more collectors' homes, go out to a few extra dinners, take that group to the Venice Biennale, and make greater efforts to really, *really*, befriend the museum's patrons?

~ ~ ~

In the conference room again. It's the next round for the Collectors Forum. Fewer people are in attendance than last time. But the atmosphere is expectant. We're only one vote away from the three finalists, the artists whose work will go on display in the galleries.

And the meeting starts with a bang. The curators call a lateral and introduce a brand new artist to the proceedings. A work has become available unexpectedly, and the opportunity for consideration is too good to pass up. The Forum members are receptive. Recaps of the other seven artists engender sedulous discussions as well, notwithstanding the fact that they mostly repeat what has been said before. But everyone's doing their due diligence, and so there's more talk about materials, viewing conditions, and the conundrum of unduly economical work.

As the presentation concludes, I can't help to think of all the artists I know who would give their left arm to be discussed in this context. After

all, there are hundreds of thousands of artists in the world. And with the fewest of exceptions, they are bound to toil in everlasting obscurity, ignored by the art world and destined to be forgotten by history.

Not so the ones on the Collectors Forum list. To be considered for acquisition by the MCA means that they are making it. With impressive exhibition records and representation from top galleries, they are building the kind of career most artists can only dream about. And while some are about to be cut from consideration by this group of donors, they are assured countless future opportunities, not just at the MCA but at all the other museums riding the crest of the contemporary art world.

But let's not dwell on the losers—after a quick ballot (totally straightforward this time), we have the three artists whose work will soon grace the MCA's galleries:

Walead Beshty. The British-born L.A.-based photographer came on the scene as a heady conceptualist, probing the political valences of the medium. But his career really took off when he started producing gorgeous, colorful photograms, marrying a deconstructive impulse with an irresistibly decorative touch. They are available in all different sizes, making them supremely adaptable for any number of environments. For the MCA, the Collectors Forum would acquire work on a museum scale of several feet.

Kota Ezawa. The Japanese-German artist works in the expanded field of photography as well. He appropriates iconic images from the history of the medium and turns them into fetching light boxes that have been popping up in collectors' homes all across the United States. For the MCA, the curators were able to locate two available pieces exceeding the living room aesthetic: a slide show of the entire project, *The History of Photography Remix*, and a three-channel video installation featuring clips of John Lennon, Susan Sontag, and Joseph Beuys. An enthusiastic screening seals it for the Forum members. It's the second piece that will be up for acquisition.

Garth Weiser. With an MFA from Columbia, the abstract painter has been on a tear lately. So desirable are his creations, in fact, that the biggest question hanging over his work is availability. Nothing viable is at hand initially. But just in time, a large red canvas with circular features

comes up. It's a classically formal piece, a "painting about painting," as one of the curators puts it.

Are the collectors completely happy with Beshty, Ezawa, and Weiser? I don't know. But a few months ago, I certainly saw lots of their work in Miami.

~ ~ ~

Meanwhile, the fundraising efforts for the Jeff Koons show are proceeding apace. Sort of.

It's not for lack of trying. For every evening with the Collectors Forum, there are half a dozen strategy sessions on ways to pay for the gateway exhibition. I am amazed at the precision of the operation. There is a veritable calculus on who could be asked for contributions, how much a potential donor might be good for, and who should be making the approach. And by the time it's all over, the MCA *can* point to considerable success.

And yet, the difficulties are easily gleaned from the pages of the catalogue. Several lenders to the exhibition, for example, end up supporting the show financially as well. It's far from an ideal situation, suggesting, rather too overtly, that collectors might be paying an institution to exhibit their holdings. But it's standard practice in this day and age (the money has to come from *somewhere*, after all), just as it is to ask an artist's galleries to help defray costs rather than merely lend work. The latter might assist with publications, an effort, standard across institutions, to avoid the impression that dealers are literally renting museums as showrooms. Sure enough, the MCA thanks "Gagosian Gallery and Sonnabend Gallery for their support of the catalogue."

But the process really hits a snag when it comes to procuring Koonsiana from private collections. The locals are particularly reluctant to part with their trophies; and in the end, only two Chicagoans, both longstanding supporters of the MCA, figure as lenders to the exhibition.

Amidst groans over declined loan requests, however, it occurs to me that the museum's aspiration to excite donors might have been misguided all along. What, after all, is in it for a lender of Koons's work? Its status won't change because of the MCA show—iconic, rarefied, canoni-

cal, it already is. Nor will it have any discernable effect on value, Koons's market having transcended the vicissitudes of individual exhibits long ago. And just seeing one's name reflected in the civic glow of a wall label is not enough. That may have cut it in the 1970s. But no more.

~ ~ ~

For donor excitement made in the aughts, there is the Collectors Forum. It's the end of May, and I'm at the banquet concluding this year's acquisition cycle. Several dozen attendees are there, seated at round tables and feasting on surprisingly agreeable fare from Puck's. Half a dozen curators and administrators are present as well, flittering about as they schmooze their way through the assembled donors. The mood is buoyant.

The works of the three finalists—Walead Beshty, Kota Ezawa, and Garth Weiser—have been on display since the second half of March. They're in a corner gallery on the fourth floor, sited amidst a number of works recently donated to the MCA. Beshty's photographic experiment and Weiser's abstract canvas share space with eye-catching pieces by Ryan Gander, Christian Holstad, Kori Newkirk, and Piotr Uklański. And while saying that they disappear into the mix would go too far, they certainly don't benefit from the context. Ezawa's installation, by contrast, occupies half of the gallery. And it shines. The artist's saturated colors come to life through ingenious computer animation, and the initial cacophony of voices untwines alluringly as viewers move underneath the three speakers suspended from the ceiling. It's been a hit with museum-goers ever since it came online.

The vote bears this out. Ezawa takes it to wild applause from the collectors, and I'm wondering how the curators feel about the selection. Their definition of "museum quality" may still elude me, but the Ezawa installation, with its elaborate spatial requirements, complicated technology, and involved polyvocality, would certainly appear to be a contender.

But the story doesn't end there. A few days after the banquet, I learn that two patrons stepped up to buy the pieces by Beshty and Weiser for the museum. All three finalists are thus entering the MCA's permanent collection.

I get a nice gift as well, though. It just so happens that a few months

before starting my research, Billy and I bought a small Walead Beshty photogram along with one of those fetching Kota Ezawa light boxes (I told you they are popping up in collectors' homes all across the United States). I never said a word about it at the MCA. But as I hear about the latest developments, I can't help thinking that, with two of "our artists" entering the museum, the value of our collection has just gone up a little.

UNTITLED (CURATION) 5

I'm lunching with a curator at Puck's cafeteria. We chat about this and that when, all of a sudden, she drops a bomb: "I really don't like *Made in Heaven*." I almost choke on my salad. "Come again," I think in disbelief; maybe I even say it out loud. Just a half hour earlier, the curator had vigorously defended the series in one of the early Koons meetings, eloquently arguing for the absolute necessity of its inclusion in the show. Now, she tells me that Koons's sculptures have a greater presence than his two-dimensional work and that *Made in Heaven* is particularly problematic. "But I still have to advocate for it," she says as she registers my shock, "it's my role."

I think about the conversation for a long time. At first, I cannot get beyond the apparent contradiction. After a while, though, it all begins to make sense. The Koons show may be driven by a multitude of agendas. But once it's on the docket, the curators approach it with the same commitments they bring to all their efforts. Those centrally include serving as the artist's representative. Koons, of course, wants to feature *Made in*

Heaven in the show; and that, along with the incongruity of barring an entire series from a full-scale retrospective, would be enough to turn the curators into advocates, quite apart from their specific feelings about the series.

As I realize over time, however, this basic responsibility only partially accounts for the curators' support of *Made in Heaven*. To them, the racy images seem to redeem the exhibit more generally, giving a much-needed charge to what might otherwise be seen as a nakedly populist show. They even have an art historical argument, something along the lines of Koons as a pioneer in the simultaneous sexualization of artistic subject and object (on account of the fact that the artist himself appears alongside the "classic" female nude). Most importantly, they see *Made in Heaven* as the kind of challenging work they want to champion. As one of the curators puts it, "it will be good for people to be confronted with it." *Ilona's Asshole* as the final stand of the avant-garde.

That last part sounds hyperbolic, I realize. But it captures my persistent sense that the MCA's curators are waging a heroic battle for the traditional values of the contemporary art museum. In this struggle for the new and difficult, they are facing the other major departments—marketing, education, development—whose structural positions can make them regard artistic intransigence as nuisance rather than virtue and the cutting edge as branding opportunity rather than call to action. It's an epic contest that plays itself out in countless little moments, many of them, on the face of it at least, quite innocuous.

~ ~ ~

I find myself, once again, in the conference room on the fifth floor. It's the weekly meeting of the curatorial department, and now, in late March, with the various Koons issues behind them, the curators are turning to the more distant future. Time to talk about traveling shows.

Like every museum of its stature, the MCA is regularly offered exhibits organized by other institutions, just as it tries to place its own shows throughout a network of likeminded venues. This kind of exchange is at the heart of the contemporary art system. It makes shows available to wider publics and allows museums to present far more varied exhibition programs than could be sustained by their own curatorial staffs. It also

serves as an important marker of institutional distinction. Sending one's shows to prestigious locations confirms a museum's standing and, on account of the loan fees, can even be a bit of a moneymaker.

At the MCA, much like elsewhere, it falls to the curators to vet the various proposals coming in from other museums. There are about half a dozen on the table for today's meeting. The chances of ever seeing these shows at the MCA are slim. Only a fraction of the proposals sent to the museum come in for serious consideration, and even those that do must clear innumerable logistical hurdles. So this is just a first look, and after a few quick eliminations (no, the MCA will not do a car show), it's on to a discussion of two major prospects: a Tara Donovan exhibit from Boston's Institute of Contemporary Art and a show of Robert Mapplethorpe's Polaroids, organized by the Whitney.

Donovan has been making one splash after another lately. Countless museums have featured her work, often in solo presentations. Those typically focus on a single, elaborate installation made from her trademark materials: drinking straws, plastic cups, buttons, pencils, and any number of other mass-produced items of everyday life. What has wowed audiences from the Hammer Museum in Los Angeles to New York's Met are the magical effects Donovan achieves with these things. Straws might morph into ethereal clouds, cups into gently rolling landscapes, buttons into coral-like stalagmites. The alchemy is always in plain view—the crowd usually peering in amazement at the hundreds of thousands of elements assembled patiently by the artist and her assistants. The Boston show is Donovan's first retrospective, bringing together sixteen of her pieces in a modestly sized exhibition.

Mapplethorpe, for his part, is a perennial favorite whose work appears in dozens of venues every year. The hook of the Whitney show is the medium. Rather than focusing on the artist's iconic creations, his carefully staged and highly stylized images of gay men and flowers, it highlights his fascination with instant photography. From 1970 to 1975, Mapplethorpe took thousands of Polaroids, many of them casual snapshots of friends, others preparatory studies for his formal photographs. Virtually unknown, the body of work affords unique insights into Mapplethorpe's process, lending the Whitney exhibition, which features about a hundred of them, a strong art historical dimension.

The curators probe the exhibits from any number of aesthetic angles. The discussion of Donovan takes up her unique approach to materials and her relation to other artists deploying everyday objects in their work. How, the curators wonder, will this creative archetype fit into art history's *longue durée*? Such questions are less relevant for Mapplethorpe, whose place in the canon has long been established. But the MCA has already hosted a major exhibit of his, and so the discussion turns on the new insights gained by a focus on the Polaroids.

What isn't discussed—and this is where it gets *really* interesting, to me at least—are audience considerations. This is not for lack of opportunity. The conversation on traveling shows lasts for over an hour. And as I listen to protracted reflections on aesthetic commitments, conceptual precedents, and the vicissitudes of art history, I think to myself how utterly different this might be if members of the marketing or education departments were present. They, no doubt, would be doing the professional equivalent of the Happy Dance. Here, after all, are two shows that are virtually tailor-made for the gateway concept. Donovan would be certain to leave visitors agape in wonder, producing the kind of word-of-mouth no advertising campaign can buy. Her delightful trickery, moreover, would be an absolute natural for Family Days: "Hey kids—come rampage through a million drinking straws and learn how to make castles out of plastic cups!" Mapplethorpe wouldn't have the child-friendly thing going on. But he would compensate with massive name recognition. He may, in fact, be second only to Warhol when it comes to *genuinely* famous contemporary artists, the kind marketers so wish there were more of in the world. Add to this the special appeal for a particularly desirable demographic—gay men—and you have the makings of a blockbuster.

But it's not to be. A variety of scheduling constraints forces the MCA to pass on the shows, and the marketers and educators never have a chance to put my fantasy into practice.

Maybe I'm falling prey to the romance of resistance. But I am deeply impressed with this little episode. Sure, I feel for the marketers and educators, deprived as they are of a tremendous opportunity to grow the MCA's audience. More than that, though, I admire the curators' uncompromising disposition, their disregard for external considerations. It's a

purism that, to me at least, embodies nothing so much as the modernist sensibility of the avant-garde.

But it feels like an isolated moment. For more sustained evidence of curatorial autonomy, I have to go into the museum's archives.

~ ~ ~

I'm reading the NEA application for the Vito Acconci retrospective of 1980—one of those daring, early shows that put the MCA on the map. At the time, Acconci had been active for just over a decade, having abandoned poetry for performance and video art at the end of the 1960s. What followed were some of the most celebrated and controversial works of the era, like *Seedbed*, in which the artist masturbated underneath a gallery ramp, and *Following Piece*, for which he picked random passersby on the street and pursued them until they entered a private space.

Shocking—maybe a little. But what I find *truly* striking from a present-day perspective is the general tenor of the application. Just as in other curatorial projects of the young MCA, there is no indication, no indication *whatsoever*, that the audience mattered. I'm not just talking about the absence of strategies to maximize visitors or optimize their experience. There isn't even an argument about how Acconci's work speaks to any issues in the culture at large.

Instead, the focus is entirely on Acconci's conceptual breakthroughs. The opening line sets the tone, identifying the artist as a "bridge linking the theatrical experiments of the Futurists and Dadaists with today's proliferation of performance arts." From there, it's on to his "ability to transform haunting internal dialogues into public disclosures" and the attendant creation in "the spectator [of] a self-awareness which retains (in memory) a residual significance." It continues like that, the only nod to Acconci's wider relevance coming in the suggestion that he is "an influential figure for younger artists."

~ ~ ~

What does an analogous document look like in 2008? Let's take a glance at the NEA proposal for the Jenny Holzer exhibit—apple and orange, perhaps, but still a ready index for some pretty significant changes. Maybe not in its essence. Much like Acconci, Holzer is presented by the MCA

staff as a formal innovator, in this case on account of her pioneering use of "language and the written word." These efforts, however, are not contextualized art historically. Instead, the focus is on the artist's engagement with the public. Once again, it is the opening sentences that tell the story: "Holzer has consistently and inventively challenged the public's assumptions about the world we live in through the use of language that conveys the multiplicity of often contradictory voices, opinions, and attitudes that form the basis of our society." No mention of minimalists, conceptualists, or any other "-ists" here or, for that matter, anywhere else in the proposal.

But Holzer's art is not only *about* the public. It's also *for* the public. There are about twenty separate assertions to that effect. The exhibit will "connect with a broad public about issues of critical social and cultural importance"; give an "opportunity for the MCA to engage a broad public audience"; showcase an "essential contemporary American artist for diverse public audiences"; etc.; etc. And it's not just generalities. A good part of the document is devoted to the specific initiatives planned to "help visitors of all ages draw relevant connections between their lives and the work on view." Those educational programs include an artist talk, a panel discussion titled "Art as an Agent for Social Change," two classes for adults—a six-week studio session on "Exploring Language and Text" and a one-day workshop, "Make Your Own Truism"—as well as numerous activities for school, youth, and family audiences.

Not all of those plans pan out in the end; the number of folks pining to make their own Truisms, for one, turns out to be rather limited. But the basic goal of audience involvement is certainly met. An entire Family Day, for example, is cued to the Holzer exhibit and features such activities as "Find Your Voice" (an improvisation workshop about "expressing yourself," for kids five and up); "Hold That Thought" ("Paint your vision of a peaceful future, then explain your thoughts to our camera"); "If I Were President" ("Create sculptures that show what you would do if you were president"); and "Promise Me Books" ("Transform an old book into a cool new book of your resolutions to make the world a better place"). For the older set, meanwhile, there is a whole series on "Art and Democracy Now." And while its slogan ends up a tad long—*Challenge it. Interact with it. Explain it. Work for it. Embrace it. Debate it. React to*

it. Celebrate it. Expect it. Learn about it. Share it. Improve it. Recycle it. Take it or leave it. Vote for it. Dream it. Inspire it. Fix it. Shout it. Whisper it. Fight for it. Honor it. Imagine it. Rally around it. Defend it. Critique it. Embody it—it does capture an institution that has moved from apathy to apotheosis when it comes to its visitors.

And so the story goes with just about every major show I see up close. Engaging, pleasing, and activating the audience—whether to impress the National Endowment for the Arts or to create institutional buy-in—has simply become an imperative for today's contemporary art curator.

~ ~ ~

So the audience has come to matter greatly. But nothing undermines curatorial autonomy more than the art market. Its stupefying growth and relentless globalization have had a totalizing effect, making it all but impossible to encounter art beyond its matrix. What this means in practice is that every curatorial choice—no matter how aesthetic, conceptual, political, or otherwise "pure" in its design—is inflected by financial considerations. And that, in turn, puts the ball right back into the all-important court of donor relations.

The discomfort of curators with this situation is betrayed by all kinds of circumlocutions. They are loathe to admit, for example, when artists are introduced to them by collectors and consistently downplay the commercial contexts of their selections. So when presenting a young, unknown artist, a curator might fess up to discovering her at an art fair in Miami, yet will be quick to note that it was not the *main fair* but one of its edgier *satellites*. And she is likely to emphasize that the gallerist didn't know that she was a curator and, rather than hoping for a quick sale, took all kinds of time to discuss the artist's intellectual project. Not as good a story as finding talent at an out-of-the-way biennial or during an unprompted studio visit in the latest artistic hotbed (Brussels today, Jakarta tomorrow?). But still better than confessing that one's museum is filled with artists favored by patrons and works that already have been, or expectantly will be, gifted by said donors.

I'm not talking about the MCA here. It is true of *every* museum collecting contemporary art.

Liam Gillick is about as avant-garde as it gets. He is part of the group of brainy artists who emerged in the 1990s under the umbrella of *relational aesthetics*, the mode of art making codified by French curator Nicolas Bourriaud. Like so many other artistic movements, it encompasses a pretty wide variety of practices. Yet all of them seek, in one way or another, to break the traditional relationship between art, artist, and viewer. To be avoided, then: the conventional presentation of objects for the consideration of passive consumers. To be pursued, instead: the creation of open-ended situations that mobilize institutions and audiences—experientially, interactively, unpredictably. That can take any number of forms: Carsten Höller's slides and merry-go-rounds, designed to align the experience and perception of spectacle; Jeremy Deller's reenactment of the *Battle of Orgreave*, part history lesson on Thatcherite England and part catharsis via mimesis; or Mauricio Cattelan's *Wrong Gallery*, hatched with curators Massimiliano Gioni and Ali Subotnick as a perpetual tease and arch critique—it was nothing but a closed door—of the gallery-going masses in Chelsea.

More than anyone else it is Rirkrit Tiravanija who embodies the methods and ethos of relational aesthetics. His 1990 solo debut—*Untitled (Pad Thai)*—set the stage. Instead of anything resembling a typical performance, let alone a conventional object-based show, he simply set up a makeshift kitchen in a gallery and proceeded to serve freshly made food to visitors, declaring the resulting situation the work of art. Over the years, the artist has staged countless variations on these themes, often involving cooking, but sometimes going even further by turning gallery and museum spaces into living quarters and literally inviting audience members to take possession of the institution. And while the art market has caught up to these iconoclastic gestures—relics like unwashed woks can be obtained from Gavin Brown's Enterprise, Tiravanija's savvy New York dealer—the artist works hard to maintain his radical edge. For his much-discussed 2004 retrospective in Rotterdam, for example, he decided to do without *any* things. There were no recreations of previous installations and no work as such. Instead, Tiravanija used texts, broadcast

into the empty galleries and deployed in audio tours, to recall the forms of sociability his creations have instantiated.

Yes, it's all very high-minded. But it still doesn't come close to Gillick, the British-born, New York–based artist who is easily the *most* cerebral of the relational aesthetes. He's also the most earnest, even a wee bit dour at times. No place for fun here. Because, let's face it, that's a huge part of the appeal of, say, Höller or Tiravanija. Sure, their work is about heady things—the phenomenology of display, radical hospitality, etc.—but the actual experience is nothing if not inviting. What, after all, can be so bad about sliding down the Tate Modern's Turbine Hall; and who doesn't love free food (although the reviews of Tiravanija's actual cooking are decidedly mixed)?

Gillick, by contrast, throws his audience no bones. Instead, they get a consistently austere mix of sleek but cryptic objects, confounding wall drawings, and variously mediated text pieces. And while these accumulations typically revolve around fairly precise referents, often historical or political in nature, the actual connections are deliberately obscured. Reviewers of Gillick's art love to disentangle the semantic webs, but for the visitor, the encounter with his work is bound to be frustrating. That, of course, is the point. As an interrogation into the structures of the public field, Gillick's work disallows any false sense of closure.

Despite or because of that, Gillick's influence is monumental. Not only are his installations seen as the epitome of conceptual rigor, but his writings, copious and very much a part of his artistic project, have made him one of the most quotable figures in the art world. MFA students inhale his output, and Europe's most daring curators—Maria Lind, Hans-Ulrich Obrist, Beatrix Ruf, Nicolaus Schafhausen—stand in line to work with him.

All of this is borne out by Gillick's mid-career retrospective. *Three Perspectives and a Short Scenario* is about as warm and fuzzy as the title suggests. What it lacks in charm, though, it makes up in intellectual heft. Rather than your conventional retrospective, which carts a group of objects from venue to venue, this one upends the very premise of the genre. In January of 2008, it opens *simultaneously* at Zürich's Kunsthalle and Rotterdam's Witte de With Center for Contemporary Art. At both

institutions, the exhibition space is segmented with a network of vaguely menacing black screens that, along with patches of gray carpet, channel viewers on a course of Gillick's prior work. Any hopes for a straightforward survey are dashed immediately, however. Previous projects *do* appear in something akin to a PowerPoint presentation. But as the images flash across the screen, they are veiled by an apparently unrelated text. A vitrine holding Gillick's publications and graphic design projects is of little help either. It is locked and doesn't allow the visitors to examine the work.

But that's just part of the scene. In a classic gesture of relational aesthetics, Gillick only exhibits in half of his allotted space, giving the other half *back* to the institution. Each venue can do what it wishes with this "institutional space." At the Kunsthalle, it is used to restage old performances by Gillick; at the Witte de With, it becomes the site of a string of solo exhibits by other artists. Things are yet different at Munich's Kunstverein, the third stop of *Three Perspectives and a Short Scenario*. There, the institutional space is deployed for a theatrical experiment Gillick is undertaking on-site with a group of local actors—an attempt to "turn the exhibition space into a stage where the phenomena of late-industrial society can be negotiated."

Pretty out there—which is why I'm amazed that the final stop of *Three Perspectives and a Short Scenario* is supposed to be the MCA. But there it is, week after week, on the draft schedule the curators discuss at their meetings. And they clearly regard the show as a coup. How could they not? As the only American venue for Gillick's retrospective, the MCA is in for some major art world cred.

Alas, it's a hard sell. For marketing, *Three Perspectives and a Short Scenario* is an obvious headache. How, after all, does one promote art whose very form militates against populism to a larger public? And good luck to education when it comes to incorporating Gillick's intervention into Family Days. Gillick's international cachet can do little to offset the basic problem, not even his stunning selection—in late spring of 2008— for the German Pavilion at the 2009 Venice Biennale, that most nationalist of art events. But then again, such unprecedented honors don't change the fact that the exhibition catalogue for *Three Perspectives and a Short Scenario* is a dense scholarly reader, published by a university

press. Jeff Koons may never even make it close to the American Pavilion in the Giardini—but his show's catalogue is a joy for all.

In the end, *Three Perspectives and a Short Scenario* does arrive at the MCA. But only after several postponements. Originally, all four iterations of the retrospective were to occur within one calendar year. It's not until October of 2009, however, that the exhibition makes it across the Atlantic, twenty-two months after its initial presentation and almost a full year since its penultimate stop. In some reviews, the specifics of the Chicago presentation will forever remain "still under discussion."

And what *does* it look like when finally arriving stateside? *Three Perspectives and a Short Scenario*, itself, appears much the same. That's if you don't glance up at the ceiling, where a site-specific installation beckons the viewer with a multihued, gridded formation not seen in the Old World. That, in fact, is the MCA's "institutional space." No performances or experiments with other artists, as there were in Europe.

But the aesthetic retrenchment doesn't stop there. In Chicago, *Three Perspectives and a Short Scenario* also provides the occasion for an orderly presentation of *stuff*. It mostly comes from the permanent collection, a selection of which is chosen by Gillick and displayed as a complement to his solo show. There's quite a bit of curatorial flair, even a whiff of the unconventional (the wall labels are studied acts of dissimulation, for example). But ultimately, *The one hundred and sixty-third floor* is a chance to assemble many of the MCA's favorites, from Bruce Nauman's irreverent objects (the museum has extensive holdings) to a suite of water towers by Bernd and Hilla Becher, one of the institution's reliable standbys. There's even an opportunity to showcase some of the recent acquisitions—with proper donor credit naturally—including work by hip youngsters Adam Pendleton and Ben Gest.

That's not all, though. What really makes the difference is the MCA's willingness to play ball with the market. And yes, Gillick has one. While most of his work—books, lectures, performances—is beyond the realm of commerce, he *does* produce a steady stream of objects for sale. Conceived at the intersection of modernist art and design, they have an elaborate theoretical superstructure that turns on the physical manifestation of social interaction. But they're also made of colorful Plexiglas and feature ingenious geometries, which is to say that they are—for lack

of a less incriminating term—*pretty*. They are ideal, in other words, for collectors who want their commitment to the avant-garde to match their interior décor.

Pretty things is certainly *not* what Gillick's retrospective is all about. But that's before it makes the voyage across the Atlantic. When the MCA presentation finally opens, it comes with an *entire room* of Gillick's most beautiful objects (presented alongside work of Jenny Holzer, Donald Judd, and Sol LeWitt under the rubric *Artists in Depth*). There is a lovely cube in blue, orange, and yellow; a gentle awning in the same hues; a charming, multicolored wall relief. It's all very soothing, a real antidote to *Three Perspectives and a Short Scenario*, whose monotonous and vaguely threatening soundtrack rumbles in the distance. And yes—closer inspection of the wall labels reveals that several objects are promised gifts to the MCA, procured with the help of Gillick's American gallerist.

~ ~ ~

"I used to be Ms. Independence," one of the curators tells me at the very beginning of my time at the MCA. She says it over lunch, and I write it down a few hours later when I have a chance to reflect on the conversations of the day. It doesn't strike me as a big deal at first. But in the course of my research, the full resonance of the phrase starts to emerge. I follow up and come to understand that *Ms. Independence* is a kind of idealized curatorial persona, divined by a young professional as yet unencumbered by the realities of the contemporary art museum. It connotes aesthetic autonomy, undiluted vision, and a remove from, even resistance against, the market. And it can't possibly be sustained—"used to be . . ."

This is not a sign of weakness, let alone a failure of nerve. If it were up to the curators, Ms. Independence would be alive and well. She certainly ruled at the *early* MCA. Not that the museum was free of strictures; no institution of its kind ever is. But without the need to maximize visitors, ensure their edification and enjoyment, and worry about paying for shows, the notion of curatorial freedom was infinitely more plausible.

Nowadays, it has become all but untenable, whether at the MCA or any other contemporary art museum. Such a thing is never said out loud, of course. If anything, museums cling to their old narratives with greater pains than ever. But the principles of avant-garde curation—the uncom-

promising search for the relevant and new regardless of audience, donor, or market considerations—simply don't accord with today's institutional needs. Those, in turn, are embodied by the departments of marketing, education, and development, and even at her most pugnacious, Ms. Independence can only hope to fight them to a draw.

~ ~ ~

Some curators tire of the battles and compromises. In March of 2008, I happen on one of them—someone who left the museum world to become an art advisor. His story is astonishing.

We meet on a Friday night at one of Rhona Hoffman's lovely gallery openings. It's been a pretty intense week at the MCA, but I'm at the ethnographic ready when a sharply dressed man in his late thirties introduces himself to me as a New York–based art advisor. I quickly learn that he holds a Ph.D. from an Ivy League institution, worked as a curator for several years at a major East Coast museum, and, following a brief stint with another consultancy, now runs his own business. He is blunt and aggressive and nothing like the art advisors I have met before. Those have tended to be middle-aged and mild-mannered, with an affect somewhere between interior decorator and visual therapist. They hold that there is a *right art* for everyone and pride themselves on finding it at minimal cost to their clients. Some, in fact, don't even charge for their services, employing a business model in which they offer their customers work at list price and take a gallery's standard 10 percent discount as commission. It's a model that is readily duplicated for corporate clients as well.

My new friend is different. There is nothing touchy-feely about his approach. No attempt to get into his clients' heads to figure out what they *truly* want or need. Instead, he describes his efforts as a continuation of his museum work—but with one major distinction: now, he actually *has* the money to realize his curatorial vision.

Over dinner, relishing my rapt attention, he explains the details. Unlike other art advisors, he doesn't work on various projects for successive clients. Rather, he is under exclusive long-term contract with three collectors; and while he does take a commission for each purchase, his cash flow is ensured by monthly retainers. I ask him why his clients would be interested in such an arrangement. "They are serious collectors," he tells

me, "and they want an expert to help them." Noticing my quizzical look, he adds, "if they had a dental issue, they would want an expert dentist. This is no different."

But what, I ask, does his expertise buy them? *Funny you should ask*, his smile telegraphs as he launches into a story about one of his recent exploits. It was at the last Art Basel Miami. Trading on his insider knowledge of the art world, he was able to snatch a major piece by Jeff Wall for one of his clients. I am duly impressed. At $500,000 and up, the price point of Wall's art is forbidding. Even more, its rarity, combined with huge demand, allows his dealer to be highly selective in *placing*—the art world's delightful euphemism for *selling*—the work. To pull this off bespeaks major access.

There's more to it, though. As I learn, with mouth increasingly agape, my new friend has a rather special relationship with his three clients. They enjoy spending time with him at art events, fairs especially, where they love to introduce him to their acquaintances. "This is so-and-so," they might say, "he has a Ph.D. from Ivy League U, and he is helping me with my art collection." To be shown off as a trophy academic does not seem to bother my new friend. But there *is* one complication. He has to make sure that he divides his time equally, lest there be jealousy among his clients. I blurt out that this sounds a bit like high-class prostitution, and, needless to say, I regret the comment immediately. Insulting one's informants is hardly considered good anthropological practice. To my utter amazement, though, he enthusiastically concurs. He actually *likes* that part, he says. It makes him feel desired.

What he likes even more is the opportunity to build the collection of his dreams. He was hoping to do so in his former curatorial position. But the realities of the contemporary art museum thwarted his ambitions. Now, he has all the acquisition budget he needs, along with clients who, he says, trust him blindly. To exemplify, he offers another recent story from Miami. He had his heart set on some works by British photoconceptualist Paul Graham. "This work is amazing," he gushed to one of the collectors. "It is truly important. You will buy something. The question is only what." And so it came to pass.

But wait, I interject. You are building private collections here. This is not the institutional stuff that creates the canon. *Wrong again*. As he

explains, his three clients are board members of one of the major West Coast museums. Not only are their works on regular view there, but they are all destined to, one day, enter its permanent collection. Given this constellation, he literally controls the museum's acquisitions.

And how is *this* for a kicker? As my new friend tells me, he was recently offered a major curatorial position at said West Coast museum. He declined, knowing full well that he has far greater influence on the institution as an art advisor than he could have as a curator. In the latter role, he would be back to begging board members and other assorted collectors for donations in the faint hope that they might accord with his aesthetic vision. In his current job, he simply buys the pieces he wants for the permanent collection. Oh, and he makes four times as much in the process—*thank you very much.*

~ ~ ~

I totally get where my new friend is coming from. Having spent several months at the MCA, I know all about curatorial cravings for influence and autonomy. And if those can be met, however counterintuitively, outside the institution, the pull is very real.

Not that contemporary art museums are in danger of running out of curators any time soon. Their departments remain small, and there is a near-inexhaustible supply of young, idealistic art historians willing to jump into the fray and start climbing the curatorial ladder. Even the first step is intensely coveted and subject to fierce competition—and that's the unpaid internship.

But the task of the curator continues to evolve. No longer centered on the quest for the new, challenging, and difficult, it has become a position of managerial mediation. Success, in this context, comes from the ability to domesticate contemporary art in ways that make it amenable to maximum audience engagement and donor involvement. The curator of the moment, in other words, is someone who can readily execute populist shows without losing conceptual credibility, reconcile institution and market without seeming like a sell-out, and build exhibitions around patrons' collections without being too obvious about it.

Ms. Independence, meanwhile, is looking into her options—and I'm guessing that art advising is looking better and better.

REN **6**

It's mid-May, and there is tremendous excitement at the MCA. The main galleries are closed. But nearly the entire museum staff is assembled to take in the spectacle: the installation of Jeff Koons's *Hanging Heart (Blue/Silver)* in the MCA's atrium.

It's a transcendent moment. One after the other, the staffers walk up to the sculpture in disbelief. At nearly nine feet tall and still resting on the museum floor, it has a stunning effect, as if the sheer size can extirpate the kitsch from the tchotchke. The piece—shiny blue heart topped with delicate silver bow—also feels like a nice reward, a pretty present for months of hard work getting the Koons show off the ground.

That said, the scene is not just celebration. It also brings to mind the enormous costs of the operation. Over the last couple of weeks, in fact, I have been hearing a lot about the escalating toll.

As I look around, I can't say I'm all that surprised. This is the most complex machinery I have ever seen in a museum context, and it is ex-

pertly handled by the crew specially flown in from Germany at Koons's explicit behest. There are several cranes in action, and when they hoist *Hanging Heart* up the MCA atrium, the staff lets out a collective gasp. Local engineers did rebuild the ceiling to allow the suspension of the piece, whose delicate looks belie the fact that it's a 3,500 pound whopper made of high chromium stainless steel. But until it is fastened securely, a certain titillation remains. It's not unlike watching a trapeze artist at work, and I, for one, can't fully shake the mental image of *Hanging Heart* crashing down on the museum floor.

There's no need to worry. These folks know exactly what they're doing. But it obviously comes at a price, just like assembling the rest of the Koons exhibit. Sure, the loans themselves are free. But the sixty works in the show have to *get to* Chicago. Hailing from twenty-seven lenders in fourteen cities and five countries, they travel, massively insured and accompanied by couriers, via land, water, and air—all on the MCA's dime. And who knew when all this was conceived that Luxembourg is the closest cargo hub to Athens big enough to accommodate the Boeing 747s necessary to fly Koons's larger works?

~ ~ ~

The gamble pays off. True, the degree of donor excitement could have been greater. But the public's response to *Jeff Koons* is huge. Whenever I stop by during the summer, the galleries are brimming with people. And visitors obviously love what they're seeing. Lots of delightedly wide eyes and brows furled in wonder—and smiles all around.

By the end of the year, the statistics bear out the success. The 2008 attendance figures set a new MCA record, with over 285,000. And while that number is still pretty far from the 500,000 annual visitors anticipated during the construction of the museum's new building, it's a marked rise from the early aughts, when attendance barely topped 200,000.

Spectacle, in other words, sells, something that is proven again in 2009, when *Take Your Time*—the Olafur Eliasson extravaganza that already packed in the crowds in San Francisco and New York—is imported by the MCA and turns into another sensation. It becomes the most popular exhibit in the museum's history and propels annual attendance above 300,000 for the first time.

This kind of growth is the dream of every contemporary art museum.
But it has real costs—in more ways than one. There's the budget itself,
of course. In the case of the MCA, it has been on a steady rise. Having
hovered around $1 million in the late '70s and doubled in the course of
the '80s, it reached close to $3 million by the early '90s. Then, in 1996,
came the new building, and the numbers *truly* skyrocketed. With vastly
more exhibition space, a full-fledged performance venue, swanky store,
and chic café, the institution's staff nearly tripled, driving the operat-
ing budget north of $10 million. And it only kept growing from there. To
properly fill the venue, marketing was further bulked up and education
enhanced, all of which required additional resources for development. By
the time of my research, in 2008, the total had swelled to $17 million, a
tremendous increase even if adjusted for inflation.

What's even greater, though, is the aesthetic cost. With the spiral of
growth churning relentlessly, the institution's ability to take risks is ever
more challenged. Does this mean that today's MCA *never* shows difficult
art? Of course not. But neither can it sustain the kind of adventurous-
ness it had during its first decades of existence. Irritation, resentment,
and rejection are built into the very fabric of the avant-garde. And that's
precisely what the museum can no longer afford. Like its peers, the MCA
is in danger of becoming too big to fail.

~ ~ ~

This book is not a broadside against the MCA or any of its American
counterparts. If anything, it seeks to defend these institutions against the
frequent accusation of *selling out*. Where others look at gateway shows,
singles mixers, and branding strategies and scoff about a failure of nerve,
I see the manifest contradiction of neoliberalism's cultural economy: mu-
seums nominally devoted to the avant-garde but forced, by the impera-
tive for growth, to compromise their commitment to the new and difficult
by embracing the entertaining and profitable.

So where *is* the avant-garde today? Arguably, where it's always been,
at least from an institutional perspective—at venues that have the free-
dom to program with few financial and populist constraints, the very

situation the MCA and its peers had in that glorious era of mid-century liberalism.

Ask any art worlder where such a place can be found *today*, and you'll hear a magic word: *Europe*. Indeed, in the generously state-supported museums across the continent, curatorial freedom reigns to an enviable degree. And nowhere more so than in the mythical *kunsthallen*, the small, non-collecting institutions that literally exist to challenge the aesthetic status quo. Neoliberal reforms threaten this avant-garde paradise as well, and European commentators are up in arms about the imminent demise of everything that's great about the art scenes of London, Paris, Berlin, or Vienna. But exhibits like Liam Gillick's *Three Perspectives and a Short Scenario* suggest, to me at least, that the Old World's support for the avant-garde remains pretty robust.

~ ~ ~

Turns out that Chicago has its own little slice of Europe. It's tucked away at the University of Chicago, in the middle of the South Side, nearly ten miles from the MCA and the Art Institute. Officially, the place has a rather ponderous name: The Renaissance Society at the University of Chicago; but everyone in the art world just calls it the *Ren*. There, at any given time, a visitor is likely to find some of the least expected, most out-there art—work that is uncompromising, uncongenial, or quite simply, unknown.

Take the exhibition program of 2008. While the MCA is getting ready to mount *Jeff Koons*, the Ren is offering up the young Czech conceptualist Katerina Šedá, followed by Trisha Donnelly, a Californian who is arguably the most confounding artist on the scene today. Šedá's installation, her first U.S. show, brings together over six hundred awkward drawings made by the artist's 77-year-old grandmother, cataloguing the inventory of the hardware store where she worked for thirty years. There's also a film documenting the project, revealing it as equal parts meditation on memory and therapeutic intervention. Hundreds of perfectly dull illustrations are a potent aesthetic challenge. But the intervention couldn't be more straightforward, especially when compared to Donnelly's exhibit, which, as is typical of her work, rejects all topicality and narrative coherence. Famously, the artist crashed one of her early openings by riding

into the gallery on a white horse, declaiming a message of surrender, and leaving just as she came. At the Ren, the theatrics are dialed down, but the visuals are no less puzzling, with a couple of randomly strewn office chairs draped in sheets of paper and featuring enigmatic scribbles.

By now, the arguments about what constitutes the avant-garde have been long-standing, and there are those who claim, not unconvincingly, that the concept itself has run its course. But if you are a modernist nostalgic like me, you still long to experience the shock of the new—and Šedá and Donnelly certainly qualify. More importantly, you believe that there could be something important and lasting to their aesthetic vision. It might be incomprehensible now and take years, even decades, to fully reveal itself. But such are the vicissitudes of what Clement Greenberg, echoing the great anthropologist Edward Sapir, called "genuine culture"—the motor of humanist creativity and true enemy of "all that is spurious in the life of our times." Or, maybe, I'm just wistful about missing the chance to walk in on *Les Demoiselles d'Avignon* or *Fountain* when they were first shown.

It would seem that I'm not alone. Chicago's cognoscenti absolutely *love* the Ren. How could they not? Here is an institution whose commitment to the most advanced art has been unwavering for decades. Founded in 1915, the organization has been a reliable champion of the avant-garde from the very beginning and has become even more so since the mid-1970s, when long-term director Susanne Ghez introduced its current *modus operandi*: between four and six shows a year, a majority of them monographic presentations—often a first institutional solo—interspersed with the occasional, always highly conceptual, group show.

And yes—I, myself, love the Ren, too. One thing I appreciate is that it's always empty. In years and years of going to exhibits there, I don't think I've ever shared its gallery with more than one other visitor, let alone a bunch of giggling middle schoolers. This is in stark contrast to the openings, always held on Sunday afternoons, which are the closest the Chicago art community ever gets to a mob scene. Hundreds of people attend, both to see and be seen and to take in the Ren's latest discovery. This, after all, is an institution that has consistently called it right, plucking artists from obscurity (or at most, early promise) and setting them on a straight path to the canon. Some of those who have

received their first major exhibits there include Joseph Kosuth (1976), Lawrence Weiner (1978), Ree Morton (1981), Nancy Spero (1984), Mike Kelley (1988), Thomas Struth (1990), Felix Gonzalez-Torres (1994), Luc Tuymans (1995), Kerry James Marshall (1998), Katarzyna Kozira (2001), Yutaka Sone (2006), and Paul Chan (2009). Is it any wonder that every— yes, *every*—aspiring curator in Chicago tells me they dream of working at the Ren?

All this sounds like the lore of a bygone era. But how is it possible *today*? How can the Ren stay in business on its steady diet of difficult shows, attended by hard-core art folks and no one else?

It's really quite simple. The Ren is absolutely tiny. It only has a half dozen full-time staffers, no permanent collection, no marketing operation to speak of (save for an essentially archival website), no real education program (unless you count its series of contemporary classical music concerts), and the most modest of development operations (centered on one annual fundraiser, the *Ren Ben*). Physically, it's small as well, with gallery *and* office spaces occupying less than half of a floor, the fourth, in a humanities classroom building. The costs for building maintenance, moreover, are covered by the university (even though the Ren is technically unaffiliated), allowing the institution to function just like a *kunsthalle*. The low overhead means curatorial freedom. And curatorial freedom means avant-garde. Yes, it's a lot like the early MCA.

But all this may be changing. Money, even the relatively small amounts required here, is harder and harder to come by. And funders— whether individual, foundation, or corporate—expect more and more recognition, along with tangible benefits, for their contributions. As a result, even the Ren is expanding. Half-time positions are turning full-time, as with the director of development, and new functions, like that of marketing associate, are being created. Surging concomitantly is the budget. As late as the mid-1980s, with a staff of three, the Ren's annual expenses were around $160,000. By the mid-1990s, the number rose to over $500,000, partly reflecting the expansion to five full-time employees. Today—with the biggest team yet, along with the ever-escalating price of contemporary art (that insurance still needs to be paid, after all)—the budget has crested at well above a million.

The spiral of growth, in other words, is catching up with the Ren. It's

still a nonprofit, and as such expansion is hardly built into its basic operating structure. Why, after all, should such an organization grow? It's not like a corporation whose unceasing enlargement is intrinsic to a profit motive built on returns on investment. But tell that to all the museums whose every expansion already entailed the next one.

Until now, the Ren has held steady on its aesthetic course. But I imagine that the siren call for the safe and popular is growing louder. And if the Ren succumbs, we would know instantly. In television, they call it "jumping the shark," after the ill-conceived *Happy Days* plotline involving the Fonz on water skis. In art, the analogous move might well be the dive into an Equilibrium Tank.

As it happens, the Ren showed Koons's iconic, floating basketballs before anyone else did, in a 1986 group show on *New Sculpture* that also featured Robert Gober and Haim Steinbach. Then, they were startling reappropriations of consumer culture's everyday objects. Today, they are emblems of an art establishment in danger of losing touch with the avant-garde.

For that reason alone, I would be happy never to see them in a contemporary art museum again. Famous last words, I know.

~ ~ ~

Other than that, I kinda like Jeff Koons . . .

Acknowledgments

Ihave incurred many debts during my time in the art world—and not just the ones involving payment plans at my favorite galleries. I owe what knowledge I have to the countless people who taught me about the ways of this strange culture, making me feel more and more at home in the process. I am tempted to venture a full listing. But such an effort would be futile. There are simply too many individuals to thank. I just hope that everyone I spoke to knows how truly grateful I am for their generosity.

It is far easier to acknowledge the institutions that made this book possible. First and foremost, that means the Museum of Contemporary Art, Chicago. It takes a special organization to allow a researcher the kind of access I enjoyed at the MCA, and I am particularly indebted to former chief curator Elizabeth Smith, who was central in making my fieldwork possible. More generally, I owe a tremendous debt to the entire staff of the museum. They tolerated the presence of this outsider with

good humor and unfailing graciousness. I very much hope that they see the resulting book as a tribute to their hard work and dedication.

In 1998, as I was finishing my Ph.D. at the University of Chicago, I had the amazingly good fortune of being offered a job at the University of Illinois at Urbana-Champaign. The campus has been my academic home ever since, and I still feel like I did when I received the call—that I had just won the lottery. The institution has given me extraordinary support for my research over the years, including, for the present project, a Humanities Released Time award (granted by the Campus Research Board). I have also had tremendous encouragement from my colleagues, particularly Luke Batten, Brett Kaplan, Harry Liebersohn, Ellen Moodie, Michael Rothberg, and Adam Sutcliffe, who took a real interest in my odd new topic.

In 2010, I had another stroke of good luck when I was appointed artistic director of the Chicago Humanities Festival. It's a fantastic organization that, for over twenty years now, has made it its mission to bring the best in art and culture to the larger public. Working with the CHF has been exhilarating. Not only that. It had a real impact on this book, giving me a valuable comparative perspective on the inner workings of nonprofits. In former CHF executive director Stuart Flack, I also found an ideal interlocutor for my work. He not only read the entire manuscript at a crucial point but taught me a lot about being an arts administrator. Through CHF, I also met Scott Falk and Jason Wejnert. I can't thank them enough for their efforts on behalf of this book.

Finally, I am grateful to the University of Chicago Press, where I had the pleasure of working with executive editor Douglas Mitchell. I met Doug twenty years ago, shortly after starting graduate school. He awed me with his accomplishments and generosity of spirit, and I am tremendously honored that he took me on as an author.

Billy Vaughn has been at my side throughout my career. He has always been my first reader and critic, and everything I think and write is better because of him. It is as another small token of my love and gratitude that I dedicate this book to him—although I was tempted to go with Elsa, our darling pug, who kept me company during the long hours of writing.

Notes

CHAPTER ONE

3 *New York's critics*: Roberta Smith, "Cars and Gunpowder and Plenty of Noise," *New York Times*, February 22, 2008; Holland Cotter, "Stand Still: A Spectacle Will Happen," *New York Times*, April 18, 2008; Roberta Smith, "Art with Baggage in Tow," *New York Times*, April 4, 2008.

3 *In Chicago*: Charles Storch, "Koons Exhibit Offers Viewing, Spending Opportunities," *Chicago Tribune*, May 26, 2008; Alan Artner, "Koons Epitomizes All Talk and No Real Vision," *Chicago Tribune*, June 1, 2008. A more celebratory tone is struck in yet another piece—Nina Metz, "Jeff Koons' Manhattan Home Is Mixture of Beautiful and Mundane," *Chicago Tribune*, May 26, 2008.

4 *Ultimately, Artner's diatribe*: Roberta Smith, "Memo to Art Museums: Don't Give Up on Art," *New York Times*, December 12, 2000; idem, "It's a Pixar World: We're Just Living in It," *New York Times*, December 16, 2006; Holland Cotter, "Beyond the Blockbusters at the Met," *New York Times*, August 5, 2010.

4 *Behind such skepticism*: Suzi Gablik, *Has Modernism Failed?* (New York: Thames & Hudson, 1984), ch. 4; Donald Kuspit, *Idiosyncratic Identities: Artists at the End of the Avant-Garde* (Cambridge: Cambridge University Press, 1996), p. 1; idem, *The End of Art* (Cambridge: Cambridge University Press, 2005).

5 *Notions like modernism's failure*: Jed Perl, *New Art City: Manhattan at Mid-Century* (New York: Vintage, 2007).

5 *This, of course, recalls*: Clement Greenberg, "Avant-Garde and Kitsch," in Greenberg, *Art and Culture: Critical Essays* (Boston: Beacon Press, 1961), pp. 10, 13, 18.

5 *For folks like Perl*: Jed Perl, "Postcards from Nowhere," *New Republic*, June 25, 2008.

5 *It is*: Julian Stallabrass, *Art Incorporated: The Story of Contemporary Art* (Oxford: Oxford University Press, 2004); Paul Werner, *Museum, Inc.: Inside the Global Art World* (Chicago: Prickly Paradigm Press, 2006); Chin-tao Wu, *Privatising Culture: Corporate Art Intervention since the 1980s* (London: Verso, 2003); Kylie Message, *New Museums and the Making of Culture* (London: Berg, 2007); Mark Rectanus, *Culture Incorporated: Museums, Artists, and Corporate Sponsorships* (Minneapolis: University of Minnesota Press, 2002); Bill Ivey, *Arts, Inc.: How Greed and Neglect Have Destroyed Our Cultural Rights* (Berkeley: University of California Press, 2010).

6 *The resulting*: Werner, *Museum, Inc.*, p. 1.

6 *Curators*: Kuspit, *The End of Art*, pp. 4, 6, 8, 12.

10 *Nothing exemplifies*: Adam Lindemann, *Collecting Contemporary* (New York: Taschen, 2006), p. 265.

10 *When I arrived*: Sarah Thornton, *Seven Days in the Art World* (New York: Norton, 2008).

11 *A touchstone*: Theodor Adorno, *Aesthetic Theory* (Minneapolis: University of Minnesota Press, 1998); idem, *Aesthetics and Politics* (London: Verso, 1980).

11 *Renato Poggioli's influential treatise*: Renato Poggioli, *The Theory of the Avant-Garde* (Cambridge, Mass.: Belknap Press of Harvard University Press, 1981), p. 106.

11 *This liberal moment*: David Harvey, *A Brief History of Neoliberalism* (Oxford: Oxford University Press, 2007); Jean and John Comaroff, *Millennial Capitalism and the Culture of Neoliberalism* (Durham: Duke University Press, 2001).

13 *I offer*: Clifford Geertz, *The Interpretation of Cultures* (New York: Basic Books, 1973), pp. 28, 331. See also the approach of Stuart Plattner, *High Art Down Home: An Economic Ethnography of a Local Art Market* (Chicago: University of Chicago Press, 1998), which uses St. Louis to generalize about regional art scenes.

15 *The MCA was founded*: On the history of the Museum of Contemporary Art, see MCA, *The Museum of Contemporary Art: Fifteen Years and Beyond* (Chicago: MCA, 1982); Marion Rainwald, *A History of the Women's Board of the Museum of Contemporary Art, 1967–1990* (Chicago: MCA, 1991); MCA, *Chicago Contemporary Campaign* (Chicago: MCA, n.d.); idem, *Collective Vision: Creating a Contemporary Art Museum* (Chicago: MCA, 1996); idem, *40 MCA* (Chicago: MCA, 2007); MCA website, http://mcachicago.org/info/about/history/1960; http://mcachicago.org/info/about/history/1970; http://mcachicago.org/info/about/history/1980; http://mcachicago.org/info/about/history/1990; http://

mcachicago.org/info/about/history/2000; http://mcachicago.org/info/about/
history/2010.

17 *In 2008*: Application to the National Endowment for the Arts for Jenny Holzer,
Protect, Protect, n.d.

18 *By contrast*: MCA, *Jeff Koons* (Chicago: MCA, 1988), p. 4.

18 *No such worries*: Franceso Bonami, ed., *Jeff Koons* (New Haven: Yale University
Press), pp. 8–15.

21 *Ultimately, I compartmentalized*: Ethics code of the American Anthropological
Association (http://www.aaanet.org/committees/ethics/ethcode.htm).

CHAPTER TWO

25 *Splashy images* : MCA, "The Comeback Kid," *MCA Magazine, Summer 2008*,
p. 5.

27 *The MCA is paradigmatic:* MCA, *Annual Report 1979–80* (Chicago: MCA, 1980);
MCA, *Annual Report 1986–87* (Chicago: MCA, 1987).

28 *Jeff Koons:* Handout "Jeff Koons Team Meeting—Agenda 2/13."

34 *In its basic design:* Institute of Contemporary Art, University of Pennsylvania,
"Karen Kilimnik," http://www.icaphila.org/exhibitions/kilimnik.php; MCA,
"Karen Kilimnik—Spring 2008," n.d.

34 *The illustrations:* MCA, "Karen Kilimnik," http://www.mcachicago.org/
exhibitions/exh_detail.php?id=66; MCA, "Beyond the Frame: Karen Kilimnik,"
MCA Magazine, Winter-Spring 2008, p. 5.

36 *Who else*: Handout "Jeff Koons Team Meeting—Agenda 2/13."

39 *Luke was nowhere:* In November 2011, 12 × 12 was replaced by Chicago Works.
The new series features local artists as well, but at all career levels and in shows
running for three months each.

40 *Indeed*: Madeline Nusser, "First Fridays at the Museum of Contemporary Art,"
TimeOut Chicago, issue 311, February 10–16, 2011, pp. 16–18.

40 *Such disregard:* Flier for First Fridays, n.d.; MCA, "And Don't Forget First Fri-
days," *MCA Magazine*, Winter/Spring 2010, p. 9.

CHAPTER THREE

41 *I love*: Fear No Art Flier, n.d. Over the last years, "Fear No Art" has fallen into
gradual disuse at the MCA. A new branding concept for the museum is ex-
pected to be unveiled in 2014.

43 *While all this is happening*: Brett Kaplan, *Unwanted Beauty: Aesthetic Pleasure
in Holocaust Representation* (Urbana: University of Illinois Press, 2007); Brett
Kaplan, *Landscapes of Holocaust Postmemory* (New York: Routledge, 2010).

49 *But children*: MCA, "I Heart Art," http://www.mcachicago.org/programs/prog
_detail.php?id=333&page=fdays.

50 *The visit*: E-mail sent from New York on February 15, 2008.

54 *The mantra*: MCA, "Barbara Kruger," http://mcachicago.org/archive/collection/
Kruger.html; MCA, "Teacher Resource Book," http://mcachicago.org/archive/
collection/.

55 *What is most striking*: MCA, "Cindy Sherman," http://mcachicago.org/archive/
 collection/Sherman1.html.

55 *The sensibility*: MCA, "Felix Gonzalez-Torres," http://mcachicago.org/archive/
 collection/Torres.html.

56 *Target*: Target, "Community Outreach: One Billion for Reading and Education,"
 http://sites.target.com/site/en/company/page.jsp?contentId=WCMP04-031700.

56 *It's not easy*: Illinois Humanities Council, "Our Mission," http://www.prairie
 .org/who_we_are/our-mission.

CHAPTER FOUR

59 *Is the work*: Roberta Smith, "Art: 4 Young East Villagers at Sonnabend Gallery,"
 New York Times, October 24, 1986; Michael Brenson, "Shifting Image and
 Scale," *New York Times*, December 2, 1988; Hal Foster, *The Return of the Real:
 The Avant-Garde at the End of the Century* (Cambridge, Mass.: MIT Press,
 1996), p. 109.

59 *I, myself*: Slavoj Žižek, *The Plague of Fantasies* (London: Verso, 1997).

61 *And operations*: MCA, "Membership," http://mcachicago.org/support/
 membership/overview.

61 *The logistical efforts*: MCA, *Annual Report 2008* (Chicago: MCA, 2009), p. 39,
 idem, *Annual Report 2009* (Chicago: MCA, 2010), p. 43.

73 *And yet*: See also Sarah Thornton's discussion of © *MURAKAMI* at the Los
 Angeles Museum of Contemporary Art in *Seven Days in the Art World*, p. 184.
 Bonami, *Jeff Koons*, p. 5.

CHAPTER FIVE

81 *I'm reading*: Application to the National Endowment for the Arts for Vito Ac-
 conci: A Retrospective, 1969–1980, n.d.

81 *What does an analogous*: Application to the National Endowment for the Arts
 for Jenny Holzer, *Protect, Protect*, n.d.

82 *Not all of those plans*: MCA, "Find Your Voice," http://www.mcachicago.org/
 programs/prog_detail.php?id=395; Flyer for *Art and Democracy Now*, n.d.

86 *But that's just part*: Kunstverein München, "Liam Gillick: Three Perspectives
 and a Short Scenario," http://archiv.kunstvereinmuenchen.de/2004-2011/
 de.01.2.liam_gillick.php.

87 *In the end*: Katie Kitamura, *Frieze*, Number 114, April 2008.

CHAPTER SIX

94 *Spectacle, in other words*: Lauren Viera, "MCA 2.0," *Chicago Tribune*, June 12,
 2011. The MCA has different methods to calculate attendance. These numbers
 are derived from the Museums in the Park consortium.

95 *This kind of growth*: MCA, *Annual Report 1979–80*; idem, *Annual Report
 1986–87*; idem, *Annual Report 1990*; idem, *Annual Report 1991*; idem, *Annual
 Report 1992*; idem, *Annual Report 1998–99*; idem, *Annual Report 2008*.

97 *By now, the arguments*: The most influential theorist of the end of the avant-

garde is Peter Bürger. See his *Theory of the Avant-Garde* (Minneapolis: University of Minnesota Press, 1984). Greenberg, "Avant-Garde and Kitsch," p. 10. Edward Sapir, "Culture, Genuine and Spurious," in David Mandelbaum, ed., *Selected Writings in Language, Culture, and Personality* (Berkeley: University of California Press, 1949), pp. 308–31.

98 *But all this may be changing*: The Renaissance Society at the University of Chicago, *Annual Report, 2006–07* (Chicago: Renaissance Society, 2007); idem, PowerPoint presentation on the history of the Renaissance Society—1976–2003, n.d.

Further Readings

Adorno, Theodor. *Aesthetic Theory*. Minneapolis: University of Minnesota Press, 1997.

Adorno, Theodor, et al. *Aesthetics and Politics*. London: Verso, 1977.

Altshuler, Bruce, ed. *Collecting the New: Museums and Contemporary Art*. Princeton: Princeton University Press, 2005.

Aronson, Marc. *Art Attack: A Short Cultural History of the Avant-Garde*. New York: Clarion, 1998.

Becker, Howard. *Art Worlds*. Berkeley: University of California Press, 1982.

Belting, Hans. *Art History after Modernism*. Chicago: University of Chicago Press, 2003.

Benjamin, Walter. *Illuminations: Essays and Reflections*. New York: Schocken, 1969.

Bourdieu, Pierre. *Distinction: A Social Critique of the Judgment of Taste*. Cambridge, Mass.: Harvard University Press, 1984.

Bourdieu, Pierre. *The Field of Cultural Production: Essays on Art and Literature*. New York: Columbia University Press, 1993.

Bourdieu, Pierre. *The Rules of Art: Genesis and Structure of the Literary Field*. Stanford: Stanford University Press, 1996.

Bourdieu, Pierre, Alain Darbel, and Dominique Schnapper. *The Love of Art: European Art Museums and Their Public*. Stanford: Stanford University Press, 1990.

Bürger, Peter. *Theory of the Avant-Garde*. Minneapolis: University of Minnesota Press, 1984.

Carrier, David. *Museum Skepticism: A History of the Display of Art in Public Galleries*. Durham: Duke University Press, 2006.

Comaroff, Jean, and John Comaroff, eds. *Millennial Capitalism and the Culture of Neoliberalism*. Durham: Duke University Press, 2001.

Crane, Diane. *The Transformation of the Avant-Garde: The New York Art World, 1940–1985*. Chicago: University of Chicago Press, 1987.

Crimp, Douglas. *On the Museum's Ruins*. Cambridge, Mass.: MIT Press, 1993.

Crow, Thomas. *Modern Art in the Common Culture*. New Haven: Yale University Press, 1996.

Cuno, James, ed. *Whose Muse? Art Museums and the Public Trust*. Princeton: Princeton University Press, 2004.

Currid, Elizabeth. *The Warhol Economy: How Fashion, Art, and Music Drive New York City*. Princeton: Princeton University Press, 2007.

Danziger, Danny. *Museum: Behind the Scenes at the Metropolitan Museum of Art*. New York: Viking, 2007.

Drucker, Johanna. *Sweet Dreams: Contemporary Art and Complicity*. Chicago: University of Chicago Press, 2006.

Foster, Hal. *Recodings: Art, Spectacle, Cultural Politics*. New York: New Press, 1985.

Foster, Hal. *The Return of the Real: The Avant-Garde at the End of the Century*. Cambridge, Mass.: MIT Press, 1996.

Foster, Hal, ed. *The Anti-Aesthetic: Essays on Postmodern Culture*. New York: New Press, 1998.

Gablik, Suzi. *Has Modernism Failed?* London: Thames & Hudson, 1984.

Geertz, Clifford. *The Interpretation of Cultures*. New York: Basic Books, 1973.

Grams, Diane, and Betty Farrell, eds., *Entering Cultural Communities: Diversity and Change in the Nonprofit Arts*. New Brunswick: Rutgers University Press, 2008.

Graw, Isabelle. *High Price: Art Between the Market and Celebrity Culture*. Berlin: Sternberg Press, 2009.

Greenberg, Clement. *Art and Culture: Critical Essays*. Boston: Beacon Press, 1961.

Grenfell, Michael, and Cheryl Hardy. *Art Rules: Pierre Bourdieu and the Visual Arts*. Oxford: Berg, 2007.

Groys, Boris. *Art Power*. Cambridge, Mass.: MIT Press, 2008.

Guilbaut, Serge. *How New York Stole the Idea of Modern Art*. Chicago: University of Chicago Press, 1985.

Handler, Richard, and Eric Gable. *The New History in an Old Museum: Creating the Past at Colonial Williamsburg*. Durham: Duke University Press, 1997.

Harvey, David. *A Brief History of Neoliberalism*. Oxford: Oxford University Press, 2005.

Hooper-Greenhill, Eilean. *Museums and Education: Purpose, Pedagogy, Performance*. London: Routledge, 2007.

Horowitz, Noah. *Art of the Deal: Contemporary Art in a Global Financial Market*. Princeton: Princeton University Press, 2010.

Ivey, Bill. *Arts, Inc.: How Greed and Neglect Have Destroyed Our Cultural Rights.* Berkeley: University of California Press, 2008.

Jameson, Fredric. *Postmodernism, or, The Cultural Logic of Late Capitalism.* Durham: Duke University Press, 1991.

Jones, Caroline. *Eyesight Alone: Clement Greenberg's Modernism and the Bureaucratization of the Senses.* Chicago: University of Chicago Press, 2005.

Kantor, Sybil Gordon. *Alfred H. Barr, Jr. and the Intellectual Origins of the Museum of Modern Art.* Cambridge, Mass.: MIT Press, 2002.

Kaplan, Brett. *Unwanted Beauty: Aesthetic Pleasure in Holocaust Representation.* Urbana: University of Illinois Press, 2007.

Kaplan, Brett. *Landscapes of Holocaust Postmemory.* New York: Routledge, 2010.

Kirshenblatt-Gimblett, Barbara. *Destination Culture: Tourism, Museums, and Heritage.* Berkeley: University of California Press, 1998.

Krauss, Rosalind. *The Originality of the Avant-Garde and Other Modernist Myths.* Cambridge, Mass.: MIT Press, 1986.

Kuspit, Donald. *Idiosyncratic Identities: Artists at the End of the Avant-Garde.* Cambridge: Cambridge University Press, 1996.

Kuspit, Donald. *The End of Art.* Cambridge: Cambridge University Press, 2005.

Lindemann, Adam. *Collecting Contemporary.* New York: Taschen, 2006.

Malinowski, Bronislaw. *Argonauts of the Western Pacific.* London: Routledge & Kegan Paul, 1978.

Marcus, George, and Fred Myers. *The Traffic in Culture: Refiguring Art and Anthropology.* Berkeley: University of California Press.

McClellan, Andrew. *The Art Museum from Boullée to Bilbao.* Berkeley: University of California Press, 2008.

Message, Kylie. *New Museums and the Making of Culture.* Oxford: Berg, 2006.

Museum of Modern Art. *The Museum of Modern Art at Mid-Century: At Home and Abroad.* New York: Museum of Modern Art, 1994.

Myers, Fred. *Painting Culture: The Making of an Aboriginal High Art.* Durham: Duke University Press, 2002.

Perl, Jed. *New Art City: Manhattan at Mid-Century.* New York: Vintage, 2007.

Plattner, Stuart. *High Art Down Home: An Economic Ethnography of a Local Art Market.* Chicago: University of Chicago Press, 1996.

Poggioli, Renato. *The Theory of the Avant-Garde.* Cambridge, Mass.: Harvard University Press, 1968.

Price, Sally. *Primitive Art in Civilized Places.* Chicago: University of Chicago Press, 1989.

Rectanus, Mark. *Culture Incorporated: Museums, Artists, and Corporate Sponsorships.* Minneapolis: University of Minnesota Press, 2002.

Sapir, Edward. *Selected Writings in Language, Culture, and Personality.* Edited by David Mandelbaum. Berkeley: University of California Press, 1949.

Siegel, Katy. *Since '45: America and the Making of Contemporary Art.* London: Reaktion Books, 2011.

Singerman, Howard. *Art Subjects: Making Artists in the American University.* Berkeley: University of California Press, 1999.

Stallabrass, Julian. *Art Incorporated: The Story of Contemporary Art*. Oxford: Oxford University Press, 2004.

Svasek, Maruska. *Anthropology, Art and Cultural Production*. London: Pluto, 2007.

Thompson, Don. *The $12 Million Stuffed Shark: The Curious Economics of Contemporary Art*. New York: Palgrave, 2008.

Thornton, Sarah. *Seven Days in the Art World*. New York: Norton, 2008.

Velthuis, Olav. *Talking Prices: Symbolic Meaning of Prices on the Market for Contemporary Art*. Princeton: Princeton University Press, 2005.

Velthuis, Olav. *Imaginary Economics: Contemporary Artists and the World of Big Money*. Amsterdam: Nai Publishers, 2005.

Weibel, Peter, and Andrea Buddensieg, eds. *Contemporary Art and the Museum: A Global Perspective*. Ostfildern: Hatje Cantz, 2007.

Werner, Paul. *Museum, Inc.: Inside the Global Art World*. Chicago: Prickly Paradigm Press, 2005.

Winegar, Jessica. *Creative Reckonings: The Politics of Art and Culture in Contemporary Egypt*. Stanford: Stanford University Press, 2006.

Wu, Chin-tao. *Privatising Culture: Corporate Art Intervention since the 1980s*. London: Verso, 2003.

Žižek, Slavoj. *The Plague of Fantasies*. London: Verso, 1997.

Index